I'D LOVE TO DRAW!

BY ANDY LOOMIS

ALSO BY ANDREW LOOMIS

FIGURE DRAWING FOR ALL IT'S WORTH

DRAWING THE HEAD AND HANDS

CREATIVE ILLUSTRATION

SUCCESSFUL DRAWING

FUN WITH A PENCIL

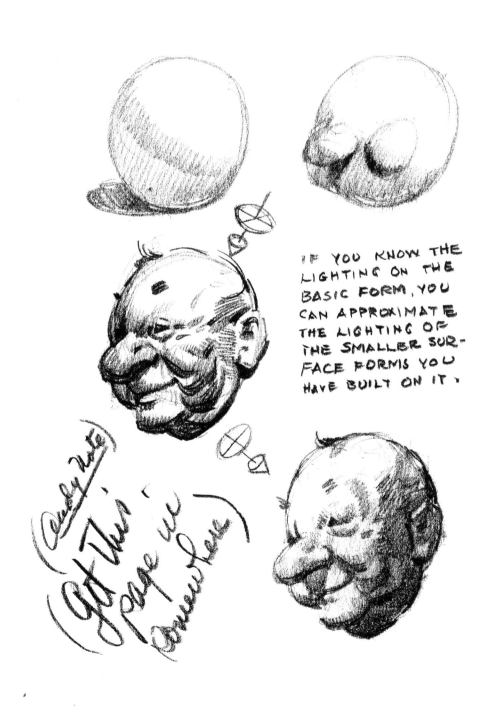

IF YOU KNOW THE
LIGHTING ON THE
BASIC FORM, YOU
CAN APPROXIMATE
THE LIGHTING OF
THE SMALLER SUR-
FACE FORMS YOU
HAVE BUILT ON IT.

I'D LOVE TO DRAW!

Andrew Loomis

With an introduction and new commentary from

ALEX ROSS

TITAN BOOKS

I'D LOVE TO DRAW

ISBN: 9781781169209

Published by
Titan Books
A division of Titan Publishing Group Ltd.
144 Southwark St.
London
SE1 0UP

First printing: October 2014.
1 3 5 7 9 10 8 6 4 2

The publishers wish to thank Alex Ross for his impressive dedication and knowledge in realizing and restoring *I'd Love to Draw*, Lou Ann Burkhardt and Richard Kryczka for their additional input, and finally, The Estate of Andrew Loomis for their enthusiasm and support.

Publisher's note: This book contains text and instruction from both Andrew Loomis and Alex Ross. For clarity, Alex Ross' text is accompanied by an initialed line to the left.

The pages included in this edition were drawn from a unique, unfinished manuscript that was hand-assembled and bound by Andrew Loomis in the early-to-mid 1950s. As such, we hope that readers appreciate that the quality of reproduction achievable can vary.

To receive advance information, news, competitions, and exclusive offers online, please sign up for the Titan newsletter on our website: *www.titanbooks.com*

Did you enjoy this book? We love to hear from our readers.
Please e-mail us at: *readerfeedback@titanemail.com* or write to
Reader Feedback at the above address.

A CIP catalogue record for this title is available from the British Library.

Printed and bound in China.

Dedicated to

DEDICATED TO THOSE WHO CAN'T DRAW.

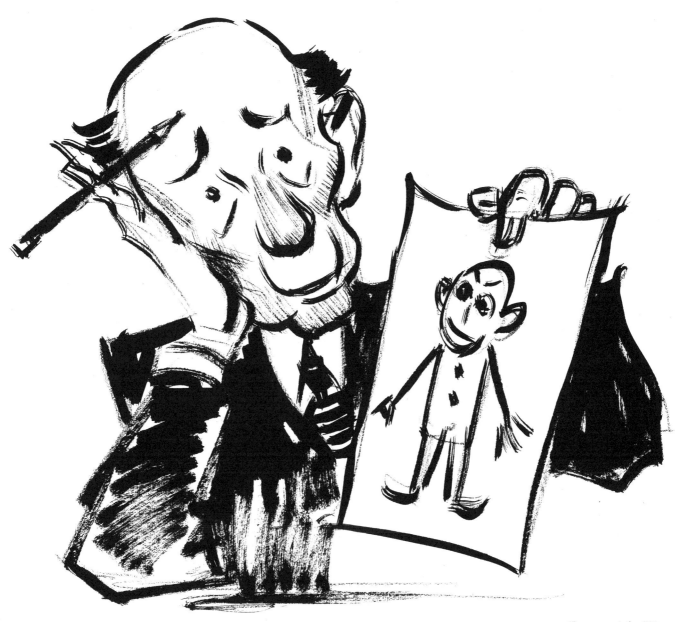

BUT ALWAYS HAVE WISHED THEY COULD.

INTRODUCTION BY ALEX ROSS

In the history of American illustration, Andrew Loomis is one of the greatest forces to shape and influence generations of artists that followed him. The success he enjoyed as a working commercial artist fed a desire to share the passion for his craft through teaching others. He did some of this in person, but primarily he wished to put down his thoughts on drawing and painting through a series of instructional books. Beginning with *Fun with a Pencil* in 1939, he created an easy-to-read, enticing manual for aspiring artists to follow and phenomenal drawing studies to inspire them. He broadened this appeal further with the now-legendary volumes of *Figure Drawing for All It's Worth* (1943) and *Creative Illustration* (1947). Loomis shared a wealth of insight from the perspective of a working illustrator, trying to prepare artists for the challenges they faced in the craft as well as the business itself. Foremost to his motivations he wanted to fan the flame in others with a love of making art. With some debate, the commercial fields he thrived in weren't always seen as 'true' art, which he argued against, and he did his best to connect with the spirit that guides all of us who want to communicate artistically.

This objective is one I would like to confirm he accomplished by the product of his hands and words reaching across many years to legions of followers like me. When my mother was a young woman in the 1940s, she set out to pursue a career in the commercial arts. She attended the American Academy of Art in Chicago, the school

that Andrew Loomis had taught at a decade earlier. Their teaching method was consistent with Loomis' approach on realistic drawing and painting. The American Academy helped hone my mother's skills to work successfully in the art field. In her journey to this goal, she purchased *Figure Drawing for All It's Worth* and *Creative Illustration* when they were first released. Her own work bears a resemblance to Loomis' style of drawing, given his influence and also coming from the same era as him.

The Loomis books were part of the Ross family library for a long time before I came along. When I was a boy in the 1970s and 80s, I would pore through these instructional books just to admire the fantastic illustrations inside. The delicate and charismatic realism of Loomis' drawings connected with me as objects of beauty to try and emulate. My normal influences ran in the realm of comic books, where wonderful art styles were largely defined by pen and ink. Illustrators like Andrew Loomis and Norman Rockwell opened up a world of elaborate rendering and lifelike illustration for me. I knew I wanted to follow their lead into letting my work become all it could be.

I followed my mother's lead eventually into the American Academy, where the legacy of Loomis' influence carried down through the decades. Forty years after my mother went there and fifty after Loomis, the heritage I gained from that school and artistic technique carried through to my career in comic art. For

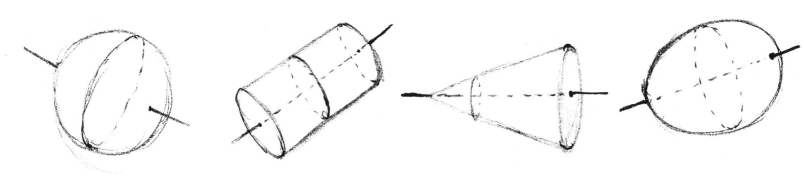

the books I've illustrated with traditional comic book panel storytelling and single image cover art, I use a painted photorealistic style. While I'm not the first to do so, the principles of basic figure drawing and hand-painted media in a comic book has remained a rare thing that my notoriety is founded upon.

In my time as a working artist, I've met many others who revered the books of Andrew Loomis. I learned that these volumes were often rare to find, and it took some work to track them all down for my collection. Helping to that end, Titan Books' new editions have been a welcome return of these works to be available again for everyone's collection and study. New students at my school have been supplied with copies of Loomis' books because of this new access.

In the body of work Loomis created through his books, a lost volume went unfinished. The book you hold in your hands was a prototype for his intended appeal to the average person who never saw themselves as a working artist but always had a curiosity for drawing. In crafting his books, Loomis would sometimes create the whole thing in dummy form, mocking up his illustrations through early rough studies and pasting in his typewritten text on the sketchbook's pages. All of these elements would be revised later for publication, but the sketchbook dummy would be used to present his ideas to the publisher and clarify for Loomis himself what worked and what didn't. Ultimately, *I'd Love to Draw* is the masterwork that got away. This rich artifact of

his ambitions to make a beginner's art manual is a fairly complete thing. With even the rough drawings for what he sketched in to go by, you'll see the clarity of his lessons and intentions. Loomis finished the main body of text for the book and no sketch is that undefined, but what he did leave unfinished are various captions throughout, accompanying the illustrations. This is the part where I come in. In my own voice, I have written these notes to hopefully illuminate the lesson plan he had in mind. I bear no ability to know his thoughts, but I try to speak plainly enough from a somewhat layman's perspective, which the book was aiming to connect with. To make sure I didn't mess up any directions he had too badly, I enlisted the aid of my teachers from the American Academy of Art in Chicago, Lou Ann Burkhardt and Richard Kryczka, to correct my writing where needed.

What we have restored with minimal alteration is a truly unique find: a missing work from a legendary figure, the incomparable Andrew Loomis. The way in which his craft is a time capsule from another era that is also timeless in its essential details astounds me still. I hope you will find this book a delight for its very existence, and, hopefully, the conversation that Andrew Loomis has made with generations of people looking to expand their talents will continue.

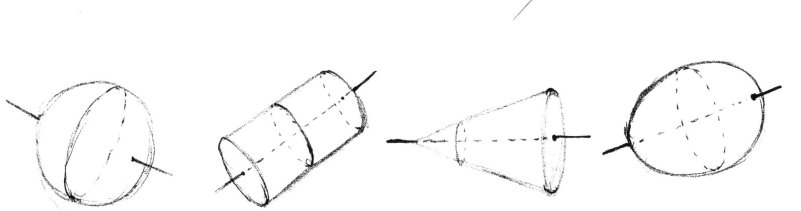

IF

YOU'VE ALWAYS HAD THE "URGE", BUT NEVER THE ABILITY, NEVER KNOWING MUCH OF HOW TO GO ABOUT IT, AND THEREFORE JUST "DOODLED" AT IT IN YOUR OWN WAY —

THEN

YOU'LL GET A BIG KICK OUT OF THIS BOOK, IT'S REALLY LOTS OF FUN.

TO KNOW MUCH ABOUT ANYTHING,
YOU MUST BE ABLE TO TAKE IT APART
AND THEN PUT IT BACK TOGETHER AGAIN.

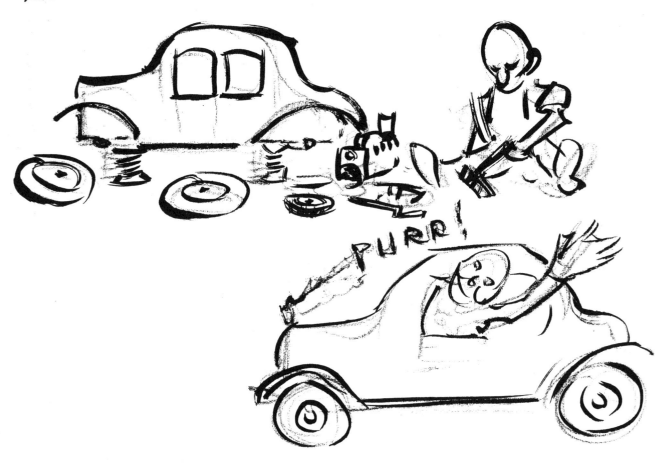

DRAWING IS ALSO JUST LIKE THAT.

THAT MEANS WE MUST KNOW HOW TO BUILD
OR "CONSTRUCT" THINGS WITH LINE - NOT
JUST "TRACE" AROUND THE OUTSIDE EDGES
AS MOST PEOPLE THINK. IN FACT YOU
START TO DRAW NEARLY EVERYTHING
WITH ONE STRAIGHT LINE DOWN THROUGH
THE MIDDLE OF IT. SURPRISED?

THEN YOU DRAW THE BULK THAT GOES
AROUND THE MIDDLE LIKE THE MEAT OF
A PEAR AROUND THE CORE.

So GET A PENCIL AND PAPER AND
LET ME SHOW YOU HOW IT ALL WORKS.

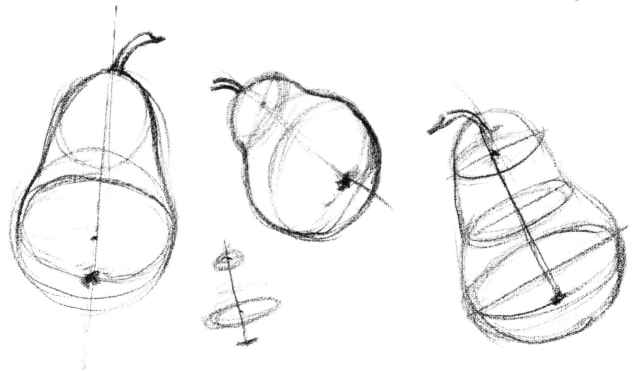

GETTING STARTED

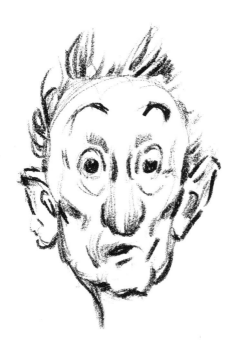

(DON'T LET THEM SCARE YOU)

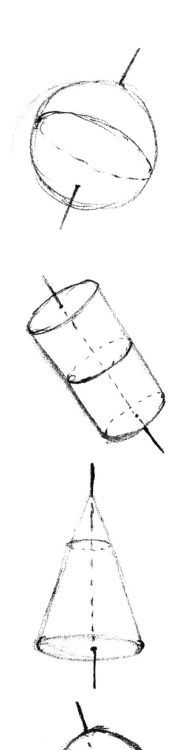

THE BASIC FORMS

Now, before we start digging up a lot of alibis about having no talent, can't draw a straight line and such nonsense, let me tell you a little about these basic forms and what they really mean to you as an artist. They are the forms, reduced to utter simplicity, which either represent or combine to represent most of the forms we know of. They are the basis of 'organized form', which means that objects have an axis around where the bulk of the form is distributed, more or less evenly. A ball or sphere is such a form. It has an axis, and the mass or bulk is evenly distributed around it. Related to the ball is the cylinder, which also has an axis, with the form distributed around it symmetrically. Next is the cone (related to the cylinder), the egg (that is really an elongated sphere), and the disc, which is really a thin slice from a cylinder, like a slice of sausage or bologna cut from the main stock, according to your appetite. These are the round basic forms and they appear again and again in familiar objects, as we will show later.

Next we have the square forms, starting with the cube. Almost anything that is angular or has flat sides belongs to the basic square forms. They are like a box— and starting with a box, we can build it into anything that would fit inside of it. Related to the cube are every kind of rectangular block. A slice of one of these is like the cover on a box, or a slab having length, breadth, and thickness.

These basic round and square forms may be combined like a dome over a square building, or a column on a square base. The human figure is composed of parts that are round, combined with angular or blocky shapes, like a round head with a square jaw, or a round forearm with a square or blocky wrist.

It is not too hard to recognize such forms, or the combinations of each. The real value of these basic forms is that we can use them as the basis by which we build more complex forms. We are not interested in balls and cylinders as such, but it makes it mighty easy to draw things that have heretofore seemed hopeless. If I say 'locomotive', we immediately think of the cylinder of the long boiler, and the box of the tender attached to the end, the discs of the wheels: all basic shapes underlying every complicated surface shape. Likewise, a market basket is a rectangular block that is still rounded by something like a half cylinder.

So, the logical place to start to learn to draw is to begin with these simple forms. Once we get the idea that it is not mere drudgery, but really the jumping off place to everything else, we become interested. Besides the organized or symmetrical forms and their combinations, we have the unbalanced or haphazard forms, which are volumes or bulk that might be anything in shape, like rocks, trees, and so forth. Yet, even in these, we can still look for the blocks and eggs, or the round and the flat. It's the simple way of looking at mass so that we understand it, and can build it as we would build a house or a hen-coop.

Let's get it out of our heads that drawing is a sort of inch-by-inch massing of what we see on the surface of things. We could laboriously copy a photo like that, but that is not really drawing. It misses the whole spirit of the thing, the analysis of what you see and feel, the individual's own interpretation.

Drawing is like writing a visual message about the life you see spread out before you. A good drawing is like a song, seen and felt by one individual. It is within your right to take your own viewpoint and analysis of the visual

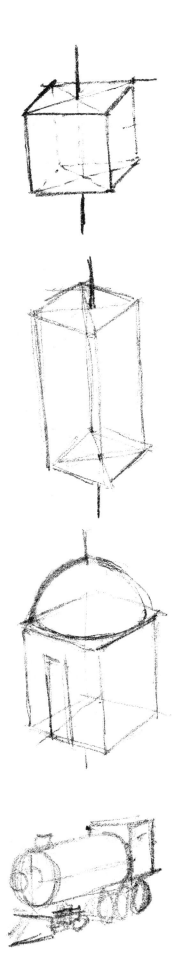

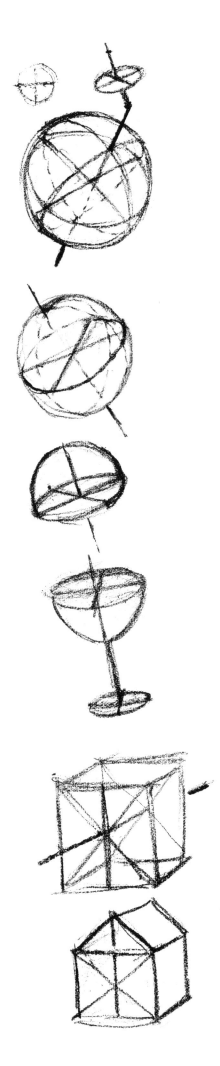

world, and to even show it as distorted if it puts your point over better, or if there is a chuckle in it. Get it out of your head that you have to do anything as anyone else does it, any more than your song would have to be just like something written by someone else.

Naturally, all songwriters have a basic knowledge of what is needed, like rhythm, chords, notes, and what-not. So, we also need a few notes that we must work with—but they are not really as difficult as writing a song. The basic forms are like tools and materials, without which we can't build anything. We simply learn to use them.

The first thing we need to do with the basic forms is to learn how to take them apart and put them together again. By subdividing them, we can find the middle line and distribute the mass evenly and correctly. We should try not to make cubes that are askew, and balls that would not roll. Many times the things we draw may be made up of parts of the basic forms—perhaps a wine glass might be half a sphere supported by a stem over a disc. We would then start with the straight line, and make sure that it is the center line of the round forms and then make sure that the round forms are distributed evenly around it.

When we have a cube, in order to get all the sides equal, we must again have a center. Every circle has a center, every cube or block—in fact, everything you draw. Much of the time we want the middle line to be on the surface, to dispose of the bulk evenly. Imagine a middle line down through a face, or, if we were going to put a gabled roof on a cube, we would have to place the ridge over the middle point of the front side of the cube. This is not as

childish as it sounds. It's amazing how many people try to draw things without outside contours, never giving a thought as to how the darn thing is put together.

It is as though all the basic forms are transparent and made of glass, so that we can see all of the edges and the middle points and lines. We can rely on the simple fact that two diagonals drawn from each of the four corners of any square or rectangle will locate the middle point where they cross.

The sphere is a little harder, so you will have to work a little longer to get it. It's like slicing an orange into halves and then quarters. Naturally, you would have to find a middle point and imagine a straight line through the ball. Your knife would pass straight through the line either way.

You would divide a disc as you would cut a pie into quarters or sixths, and, if you are not too hungry, eighths. Suppose this disc or circle is at the top of a cylinder. You could then cut the cylinder into equal parts or sections. Later on, we will draw things in perspective just this way, for we have to know our lines all around and through the object. Then we can draw it correctly. Let us take a few familiar things and show how we use the basic forms.

I suggest that you start with your pencil and draw these forms and objects. If you want to use a straight edge, go ahead. Try to draw your ellipses evenly, measured carefully on each side. It's hard to see that this has anything to do with pretty girls or funny faces, but take my word for it, it has.

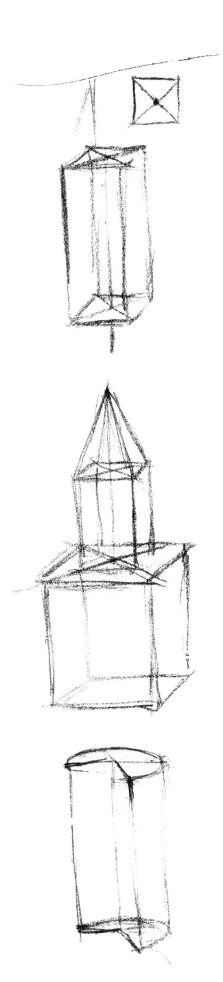

A BALL IS A SERIES OF WHEELS ON THE INSIDE, ALL WITH A COMMON CENTER. DRAWING JUST A CIRCLE GIVES US A FLAT DISC. A BALL IS MORE THAN JUST THAT. SEE, IT'S LIKE THIS.

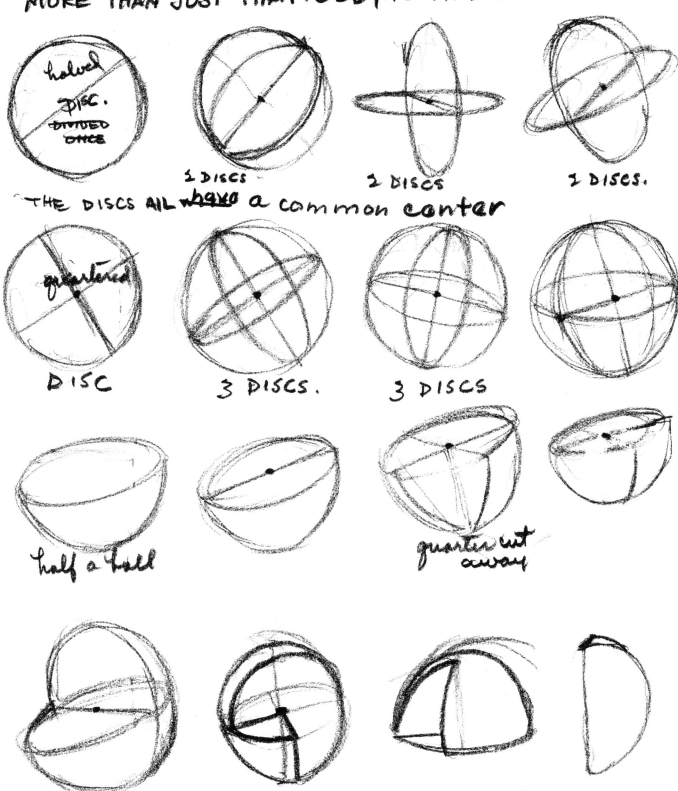

halved DISC. DIVIDED ONCE

2 DISCS

2 DISCS

2 DISCS.

THE DISCS ALL have a common center

quartered

DISC

3 DISCS.

3 DISCS

half a ball

quarter cut away

OUT OF THIS WE DRAW AN ORANGE
CUT IN HALF OR SLICES
CUT UP A REAL ONE AND DRAW IT

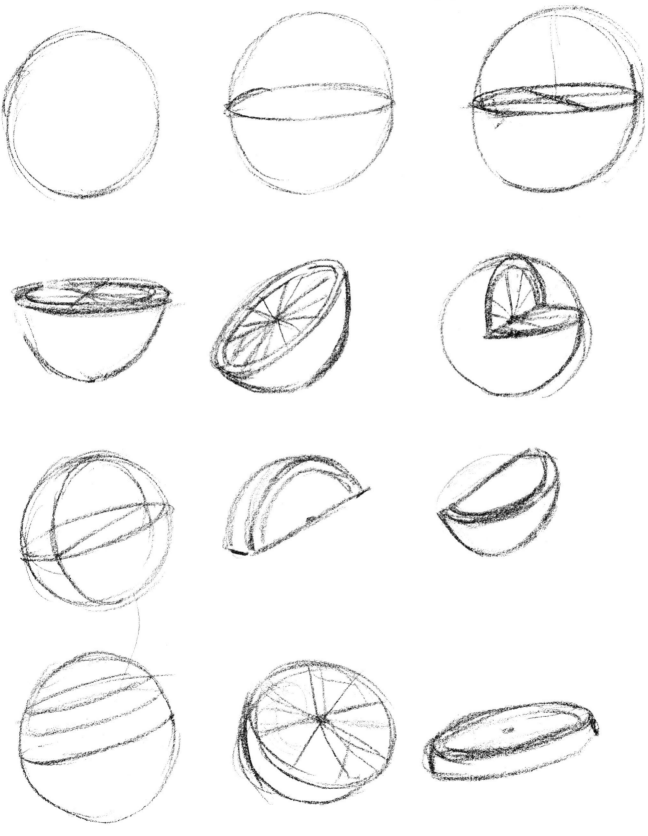

17

A DISC IS TWO PARALLEL CIRCLES.

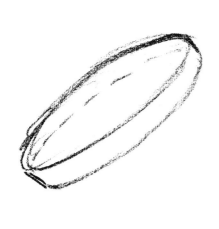

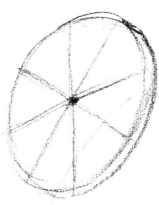

DIVIDED

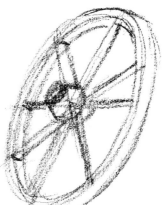

IT BECOMES A WAGON WHEEL

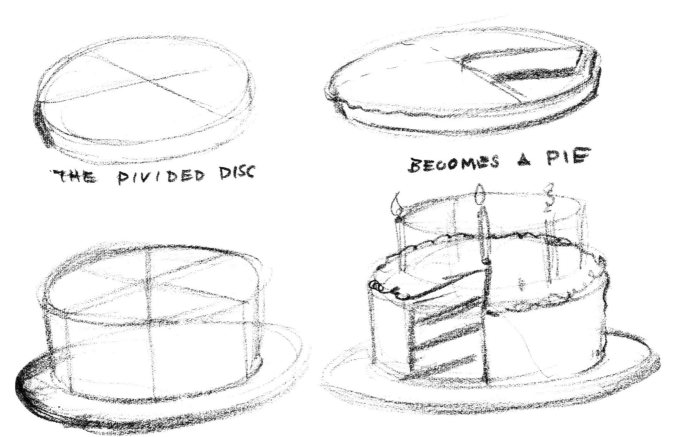

THE DIVIDED DISC

BECOMES A PIE

THICKER, A BIRTHDAY CAKE.

We know a wheel is perfectly round
Looking at it flatly it is simple to draw

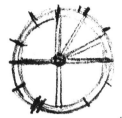 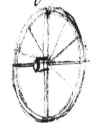 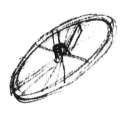 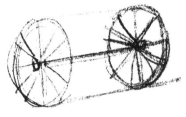

DIVIDE IN 4th
THEN DIVIDE THE
4ths.

IF THE WHEEL
IS TURNED THE
CONTOUR BECOMES
AN ELIPSE, BUT
THE DIVISIONS REMAIN

IN ANY POSITION
OUR BASIC
CONSTRUCTION
IS THE SAME

TWO WHEELS
ON AN AXIS
PRACTICALLY
DUPLICATE EACH
OTHER IN CON
STRUCTION AND
CON TO U R,

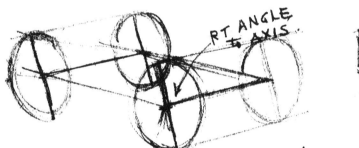 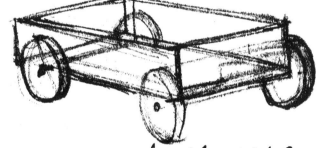

RT ANGLE
± AXIS.

we construct our drawings as if all were
made of glass and we could see through
Our object becomes opaque by erasing all
but the visible contours. If we can draw
a wheel we can draw a cylinder

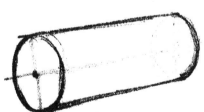

or a cone or a vase

for the sections are all wheels on a center line.

COMBINATIONS OF BASIC FORMS

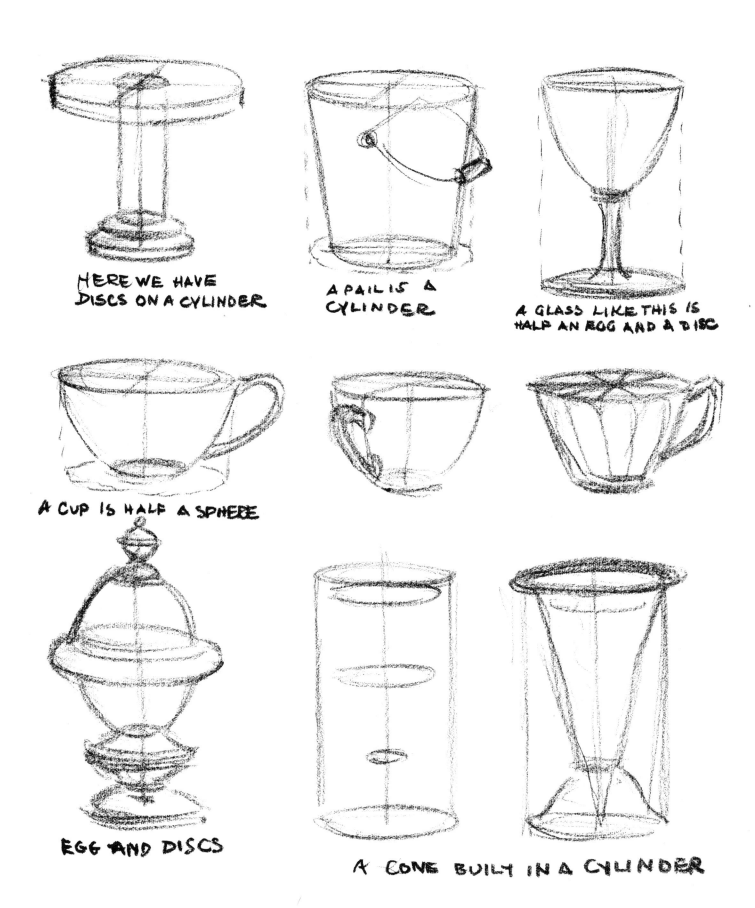

HERE WE HAVE
DISCS ON A CYLINDER

A PAIL IS A
CYLINDER

A GLASS LIKE THIS IS
HALF AN EGG AND A DISC

A CUP IS HALF A SPHERE

EGG AND DISCS

A CONE BUILT IN A CYLINDER

LOOK FOR THE BASIC SHAPES

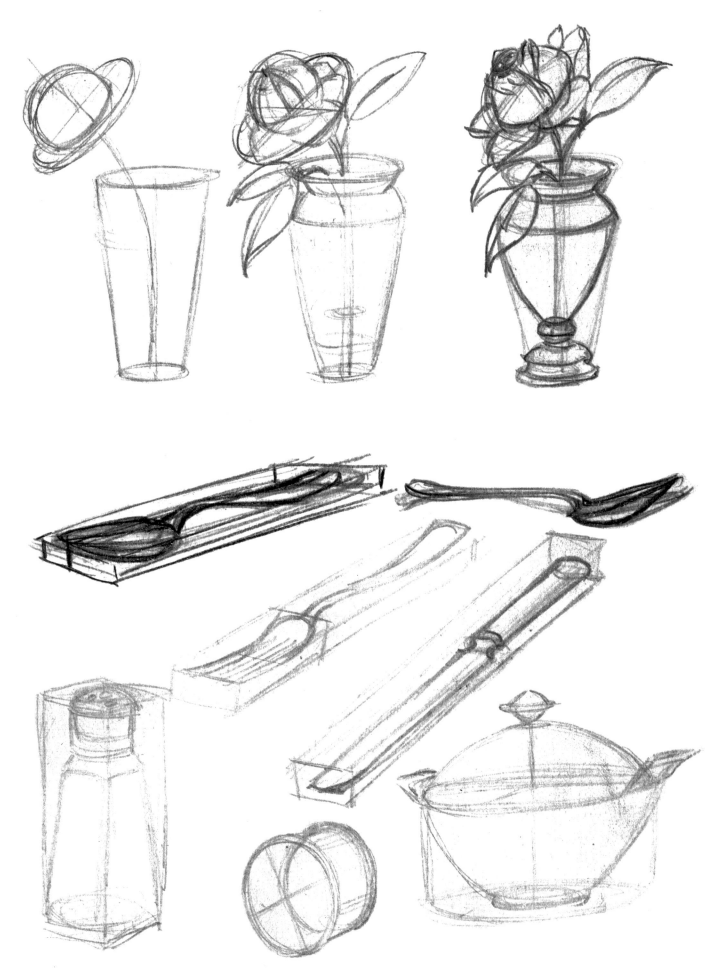

BUILDINGS ARE BLOCKS.

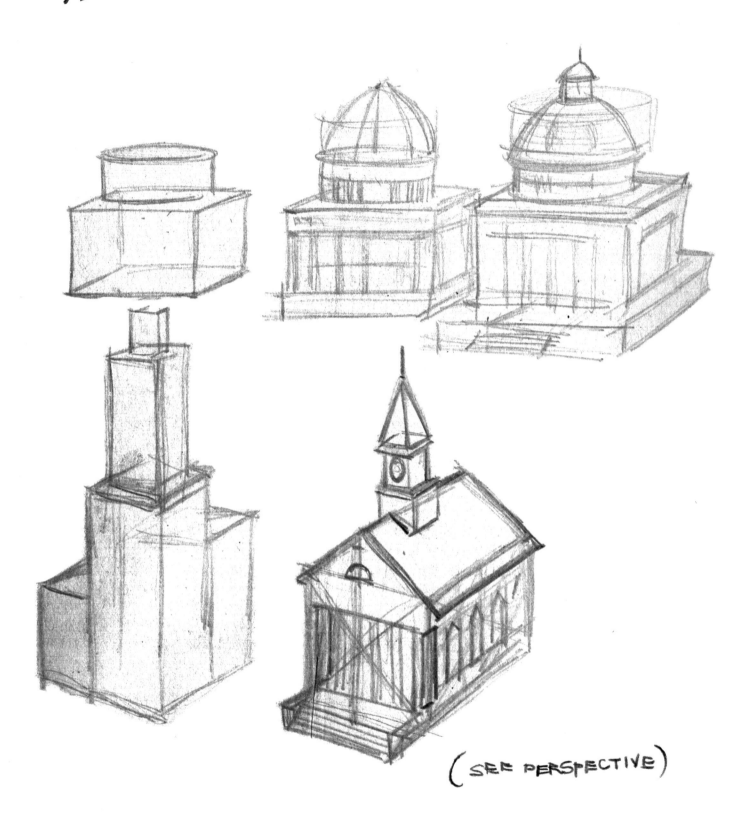

(SEE PERSPECTIVE)

GATHER UP SOME OBJECTS AND DRAW THEM.

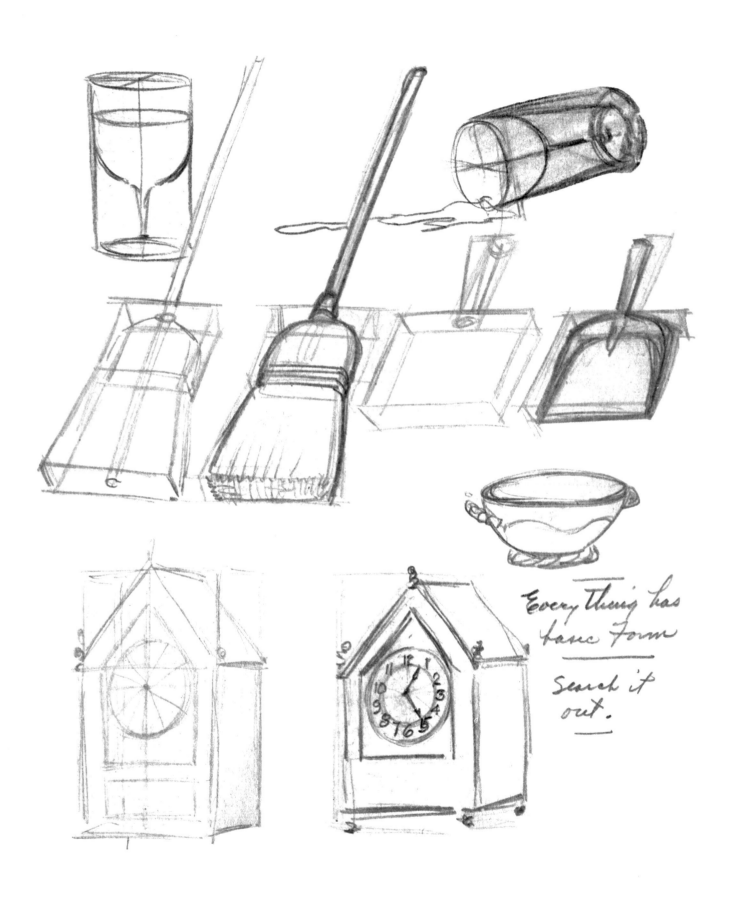

Everything has basic form

Search it out.

THE HARD SUBJECT BECOMES EASY.

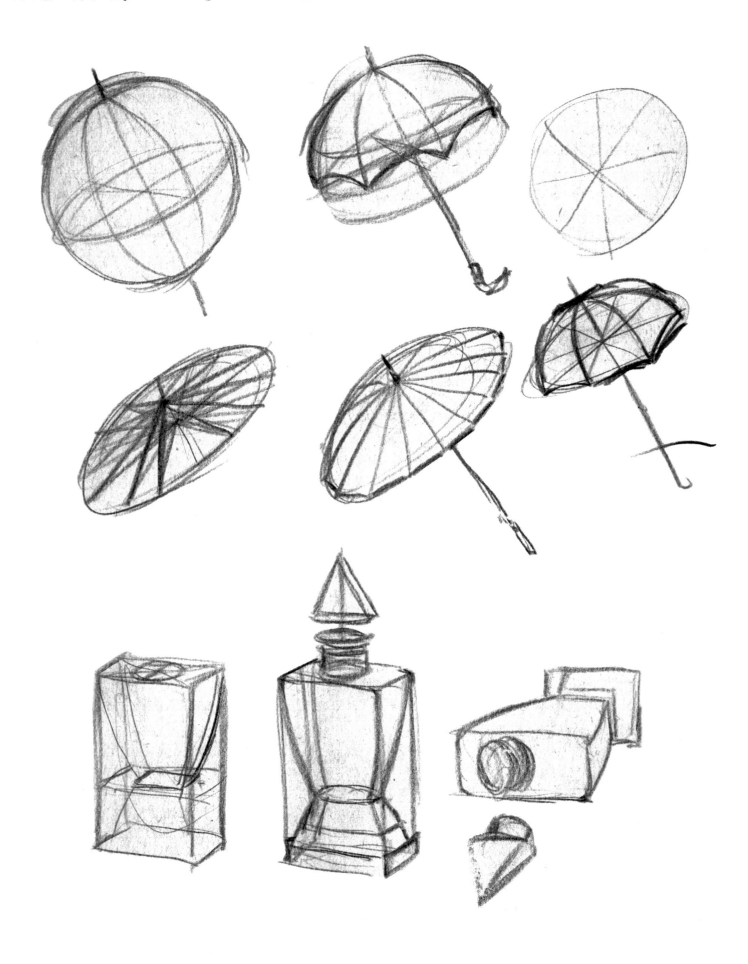

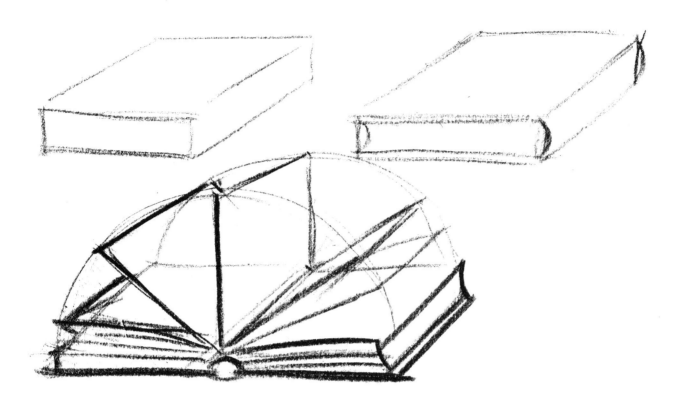

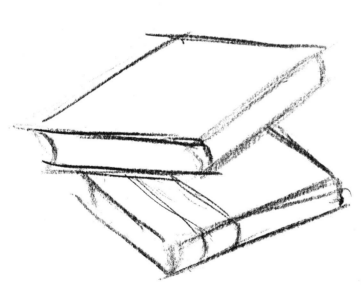

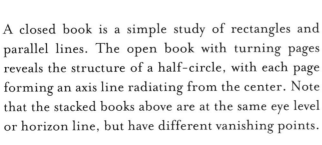

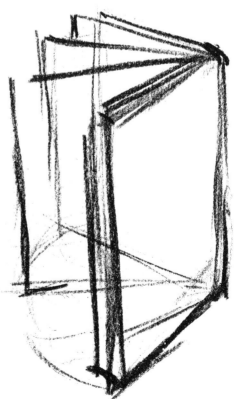

A closed book is a simple study of rectangles and parallel lines. The open book with turning pages reveals the structure of a half-circle, with each page forming an axis line radiating from the center. Note that the stacked books above are at the same eye level or horizon line, but have different vanishing points.

AR

25

You wouldn't believe a revolving door is based on a tin can, or a tire on a cookie!

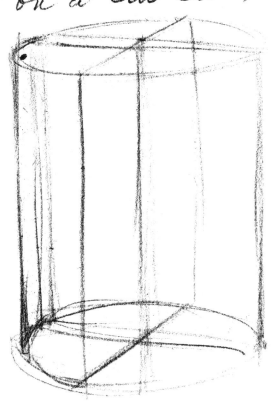

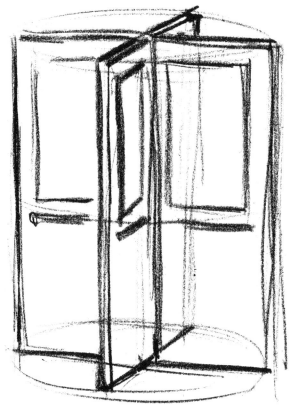

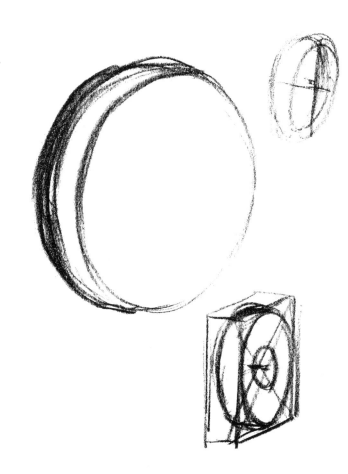

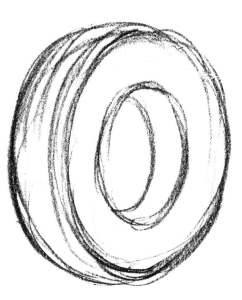

A TIRE IS JUST
THE SAME OLD DISC.

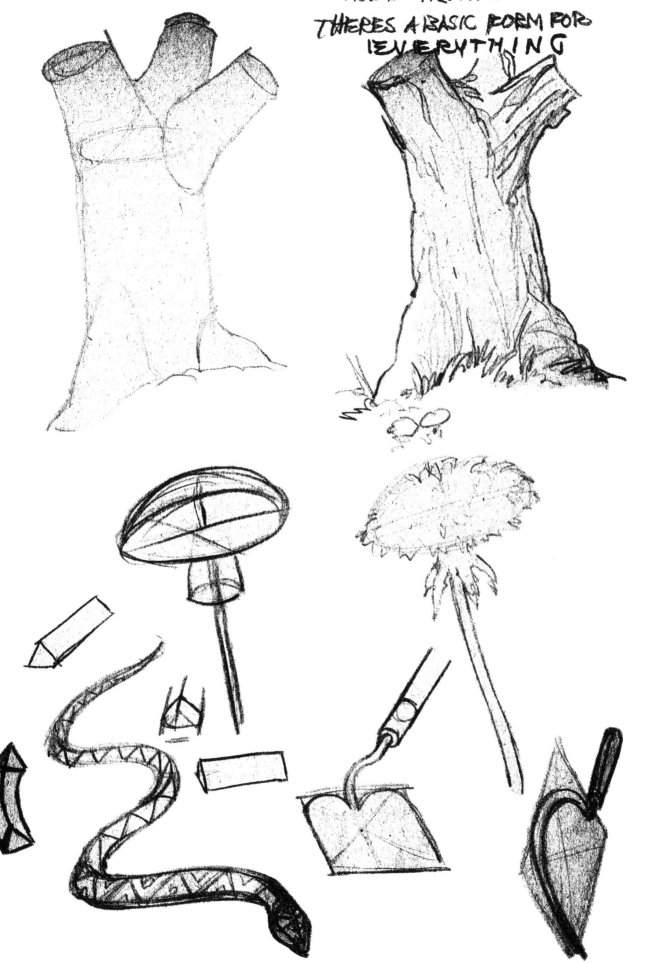

TREE TRUNKS ARE CYLINDERS
THERES A BASIC FORM FOR
EVERYTHING

BLOCKS AND CYLINDERS

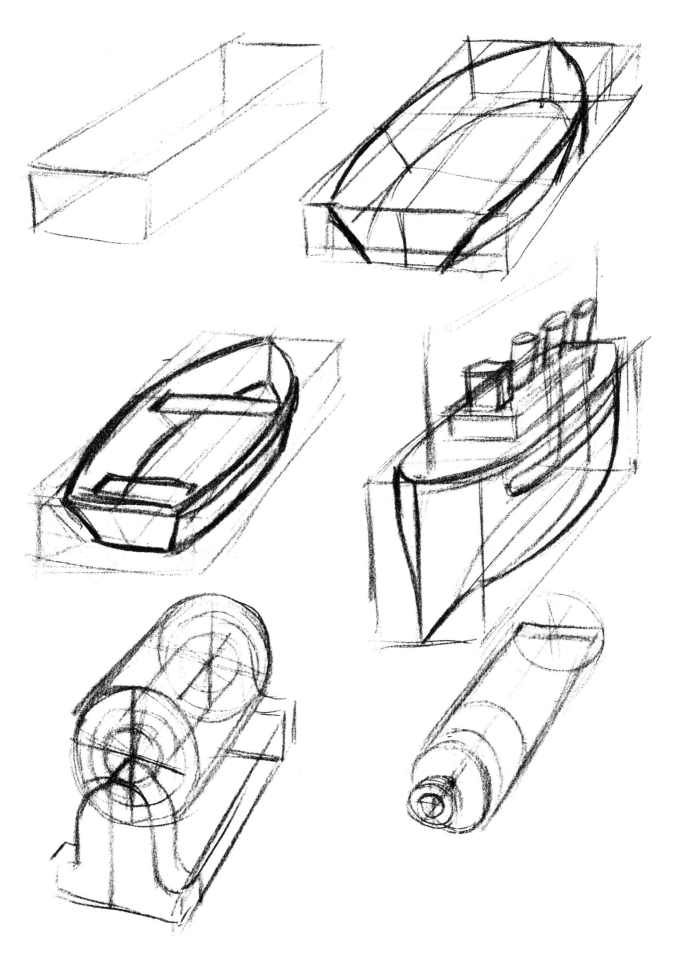

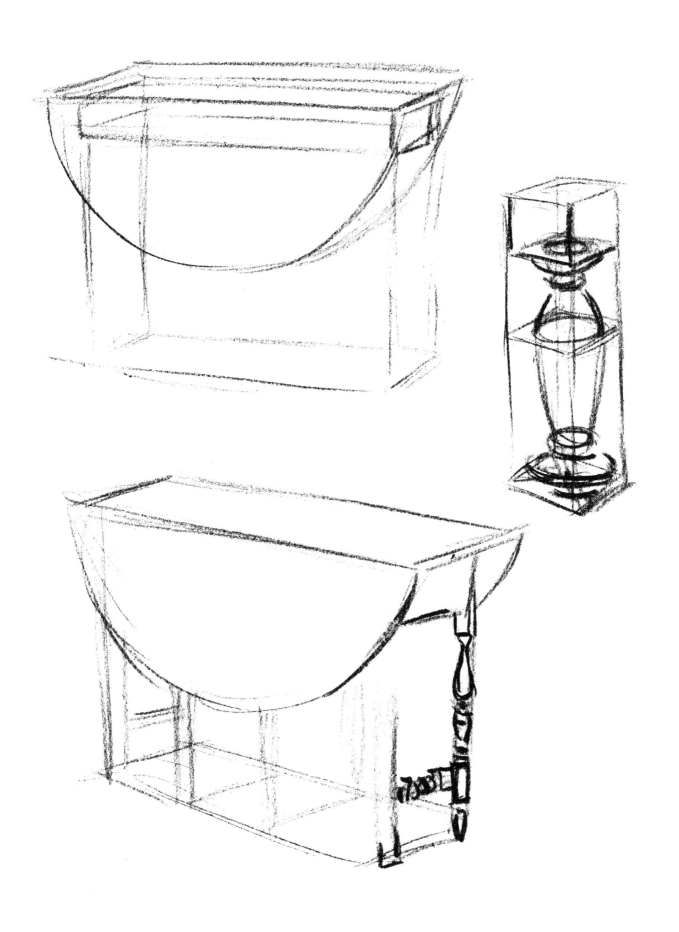

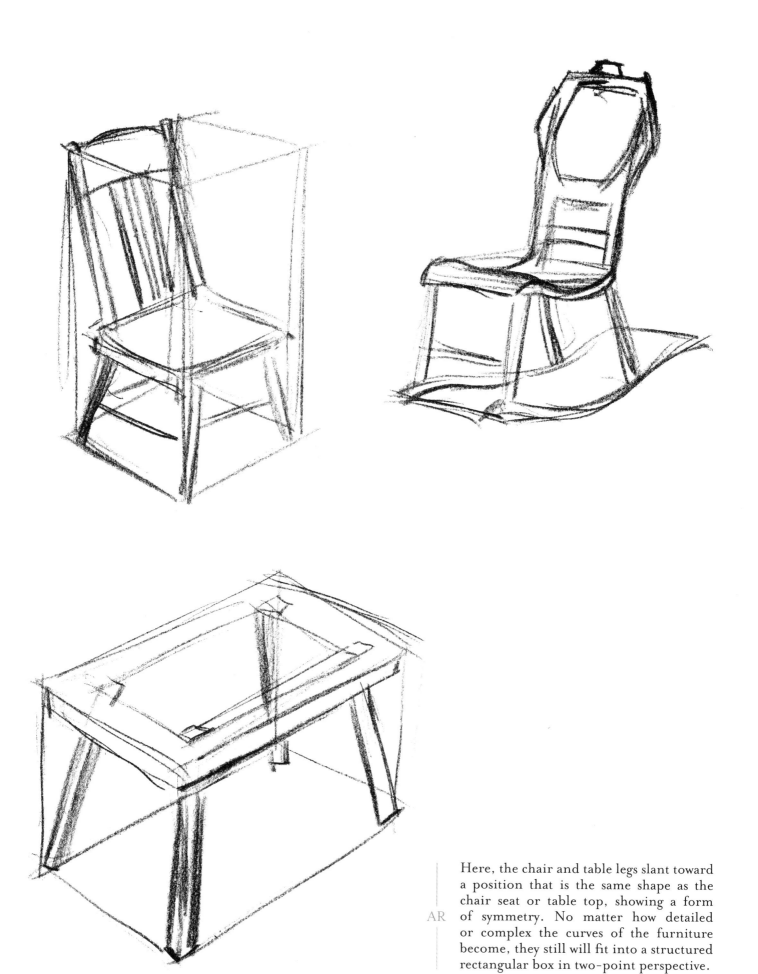

Here, the chair and table legs slant toward a position that is the same shape as the chair seat or table top, showing a form of symmetry. No matter how detailed or complex the curves of the furniture become, they still will fit into a structured rectangular box in two-point perspective.

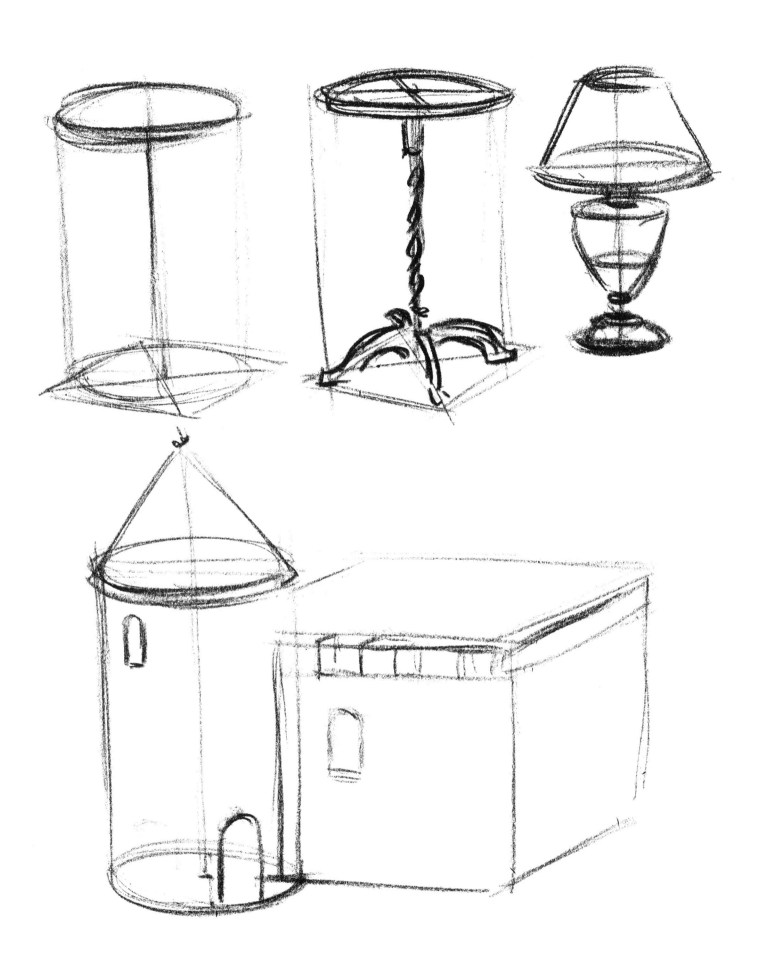

PERSPECTIVE

Now, if you have been drawing some of the things leading up to this point, you may have had a little trouble getting your blocks and cubes square and in proportion. The real difficulty is that little old puzzler some bright guy named 'perspective'. Perspective really just means viewpoint or point of view. Don't worry, it's not going to be too complicated, but you'll have to keep your wits about you. Shut off the old radio for a little while and concentrate. Perspective really affects everything you draw, and has always been one of the main reasons more people can't draw. It's something like learning notes and bars, but not so hard.

You have an eye level that is always with you. You can't escape it—everything you look at is affected by it. You either look over the top of things or up at them. You can't be in more than one spot at one time, so that is your station point, the point from which you can see things. At the breakfast table your eye level is above the things on the table, so you see right into your plates and cups or glasses.

When you go down the street later on, your eyes look up at buildings. You can't see over the tops of things. Now, in perspective, all things below the eye level seem to slant or pitch upward to your eye level, and all things above your eye level seem to slant down. As you look at the ceiling and far wall, the lines of the walls and ceiling seem to slant downward, and if carried far enough into the distance would almost seem to converge in a dot or a point. Such a dot is known as the vanishing point. A good example of this would be looking all the way down a long straight highway or railroad track. This is called single-point perspective. Now, if you were standing away from the corner of a building, you would see something different. The building appears highest at the close corner and the two sides seem to slant down to the horizon. Therefore, the sides of the building each slant down towards a vanishing point. As you may have guessed, this is called two-point perspective.

A strange thing happens. The actual horizon or level line of the distance is always at your own eye level. You can't get above the horizon or below it, but everything else can — and does. Even if you are high up in an airplane, the horizon simply moves out farther, and if it were clear enough, would always remain at your own eye level. Your eye level follows you down even ten storeys underground. The ceiling in the room way down there would do just the same as in a room ten storeys up. They would slant downward to a point in a line at your eye level. The lines that appear level without slanting upward or downward are at your own eye level. Notice this in a brick building that you are looking at diagonally. The line of bricks that neither slant up nor down will be exactly at the height of your eyes in relation to the ground.

When the basic forms are relatively small, like a shoebox or a single brick, we see relatively little convergence around the edges or contours. When it's a big building, we see much of it. That is really what identifies a thing in a drawing as a large object or a small one. But the perspective is there, just the same. The back end of a block can never be seen quite as large as the close end.

In round objects there is no apparent effect of perspective on the contour. They are perfectly round from any viewpoint. But, were we to cut the ball in half, it shows how perspective can even affect a ball. Below our eye level, we look into the ellipse like a cup; above our eye level, the edge curves up and we do not see any ellipse, only the front end of it. So the width of the ellipse depends upon the viewpoint from which we see it. For example, were it transparent, we would see a wider ellipse at the bottom of a cylinder than at the top, because it is further below the eye. Thus, horizontal ellipses or circles seen in perspective narrow down as they approach eye level, and become wider and rounder as they drop below it. They widen again as they go upward, even if we only see the edge toward us—but we would always draw the whole ellipse as if the material were transparent.

When you want to know what the perspective of an object is at any point within that object, try to imagine the object cut apart at that point. Such perspective is really there in all opaque objects, and they are really the construction lines carried around the object. We only see the visible aspects of perspective as though all the construction lines inside and out were erased. In that sense, all we see is the finished state of things, the outlines and contours, but we must know the invisible contours that are hidden from us. It is not any harder to draw the back end of a block than the front end, and it tells us where the lines go that are invisible. In so many words, the real draughtsman draws the whole thing, all around, not just the visible front portion of it. That's the difference between drawing and tracing or copying. When we do that, we are just filling so much space without really understanding what we are drawing.

By using perspective, we are able to subdivide the basic forms in order to know just how far back we should go. Distances tend to shorten as they reach the eye level, just as they do in ellipses— that is, they narrow down. A distant square on the sidewalk seems much narrower to the eye than a close one. We know they may all be equal, but perspective is our means of drawing them to appear farther and farther away.

We can find a way to measure such sections by using diagonals, which is the same old principle of taking things apart and putting them back together. Thus, we can measure from one to another.

We will not go into complicated perspective, such as sloping or uneven ground planes, nor the intricate scaling of perspective, as done by the architectural draughtsman. If you are interested in carrying your knowledge further, I suggest you get a good book on perspective. One such inexpensive book is titled *Perspective Made Easy*, by Ernest Norling.

Perspective is really a method of foreshortening what we see so that it appears as it would to the eye or to the camera. The camera, of course, proves that the slanted edges and so forth are really there, and actually exist in our vision. Without perspective comes distortion, and what we'd call 'bad drawing'. If your drawing has been bad, you may be sure that the biggest reason is that you do not understand simple perspective.

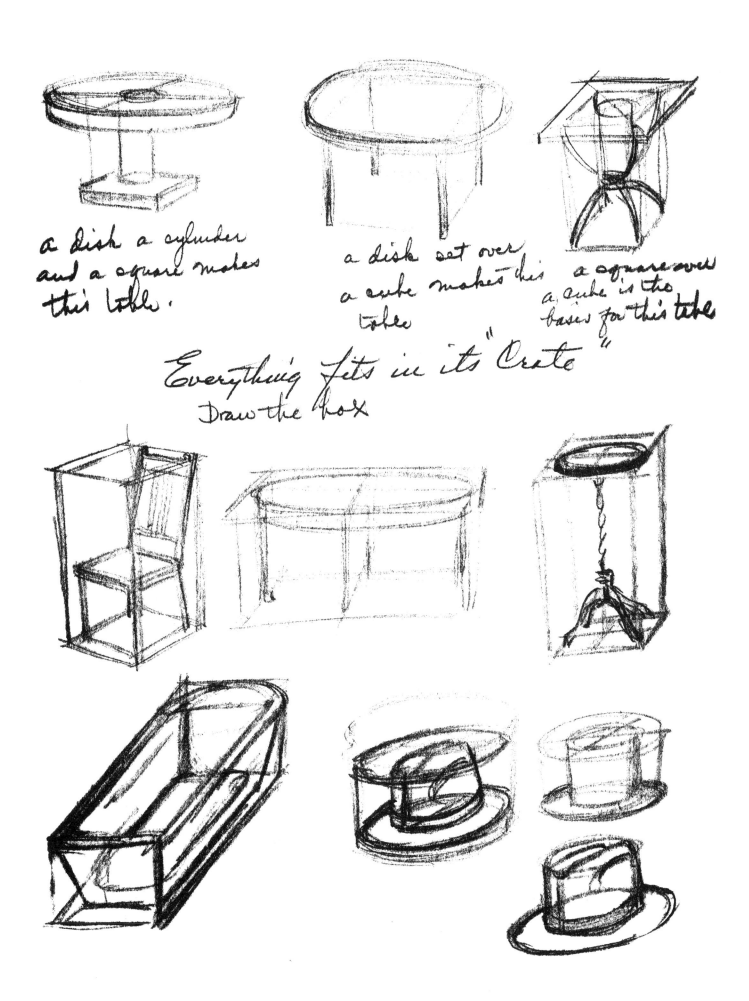

a dish a cylinder
and a square makes
this table.

a dish set over
a cube makes this
table

a square over
a cube is the
base for this table

Everything fits in its "Crate"
Draw the box

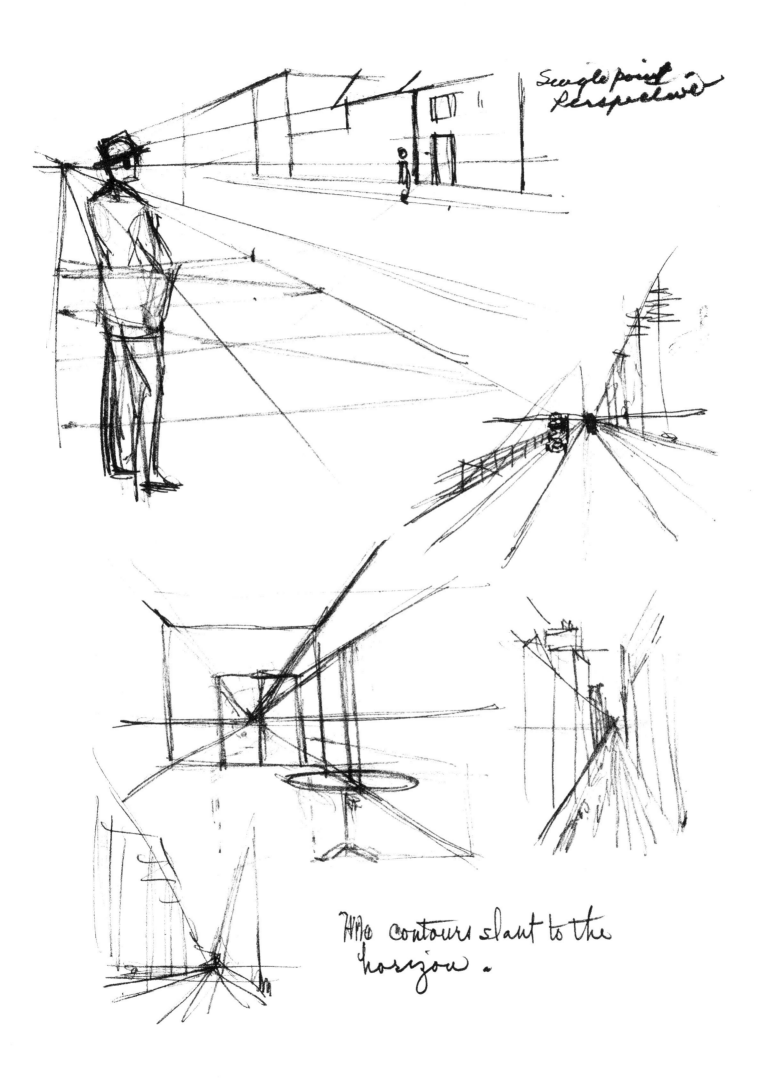

Single point
Perspective

The contours slant to the
horizon.

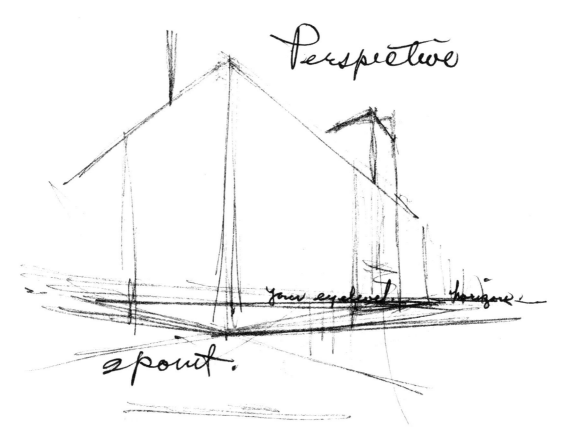

Perspective

Your eyelevel · horizon ·

2 point.

Almost always there is the chance to face two-point perspective where the angled shape of the object has two descending angles that point to the horizon. The horizon doesn't change, but the slant of the building's frame toward it isn't necessarily the same on both sides. Any internal lines within the building (like windows, ledges, patterns, etc.) would also go to the same low eye level line, which means the viewer is looking up toward the building.

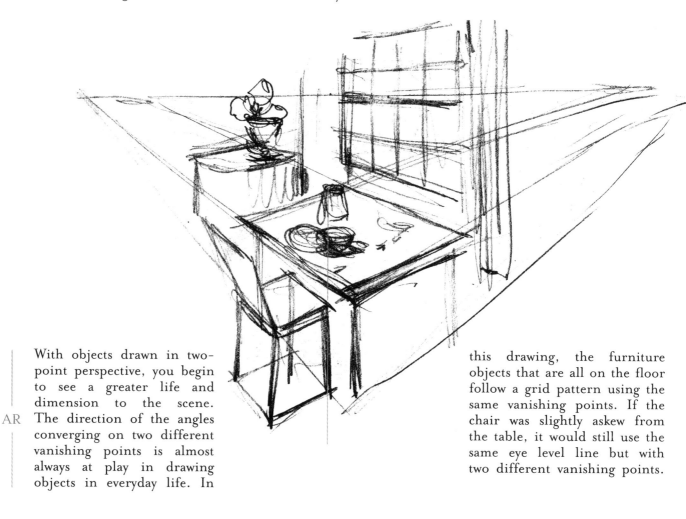

With objects drawn in two-point perspective, you begin to see a greater life and dimension to the scene. The direction of the angles converging on two different vanishing points is almost always at play in drawing objects in everyday life. In this drawing, the furniture objects that are all on the floor follow a grid pattern using the same vanishing points. If the chair was slightly askew from the table, it would still use the same eye level line but with two different vanishing points.

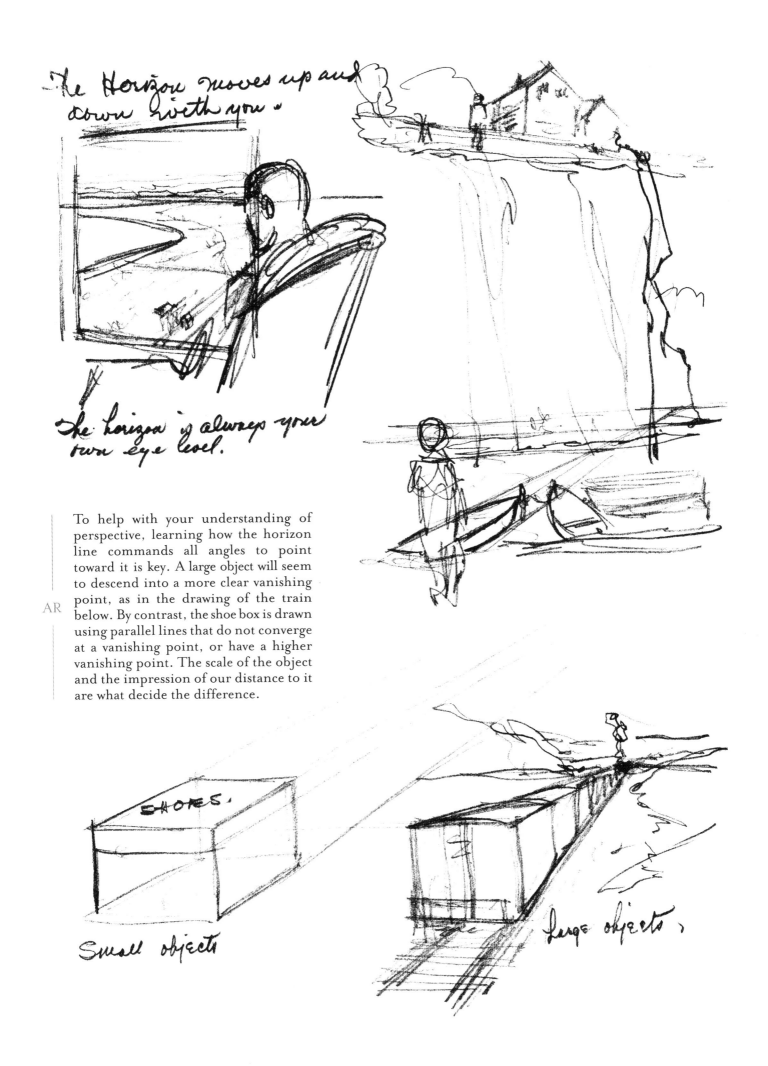

"The Horizon moves up and down with you."

The horizon is always your own eye level.

To help with your understanding of perspective, learning how the horizon line commands all angles to point toward it is key. A large object will seem to descend into a more clear vanishing point, as in the drawing of the train below. By contrast, the shoe box is drawn using parallel lines that do not converge at a vanishing point, or have a higher vanishing point. The scale of the object and the impression of our distance to it are what decide the difference.

AR

SHOES.

Small objects

Large objects.

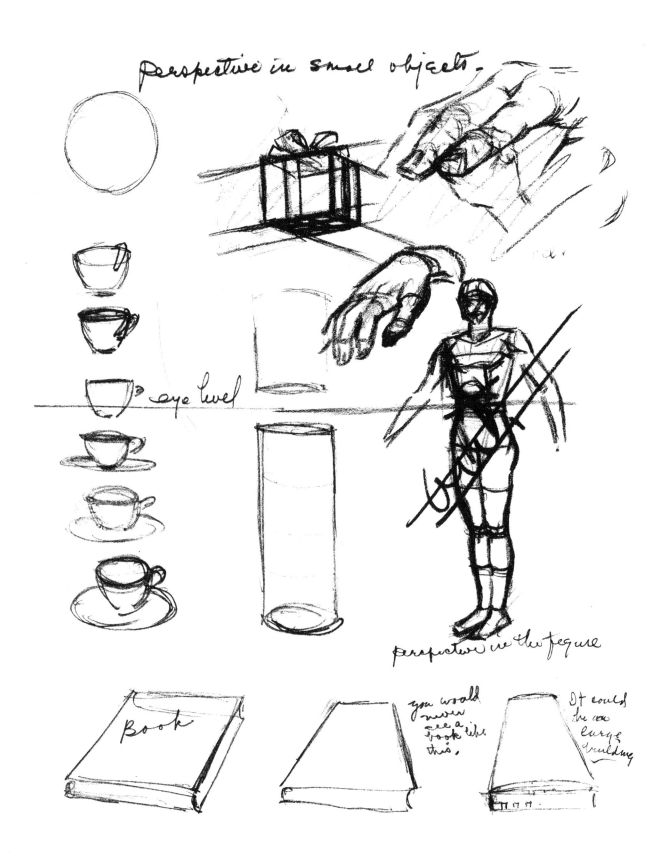

Studying a small object like a cup allows us to understand the nature of a basic circle in perspective. From either above or below the view of the cup, we see widening or compression of the ellipses of its shape as we angle our view of it. These same ellipses are occurring within the cylindrical shapes of fingers or the legs and trunk of the human body.

The perspective lines on smaller objects will not angle as dramatically as larger structures. The distance to the back edge of a book will not show a difference in width substantially, but they still taper to the same eye level. A building, by contrast, would show a much larger shift in the size of the back end to front end seen in perspective. If, say, we were flying in a plane high above a building, its overall shape might be the same as looking at a book from up above in perspective.

GETTING THINGS ON THE GROUND

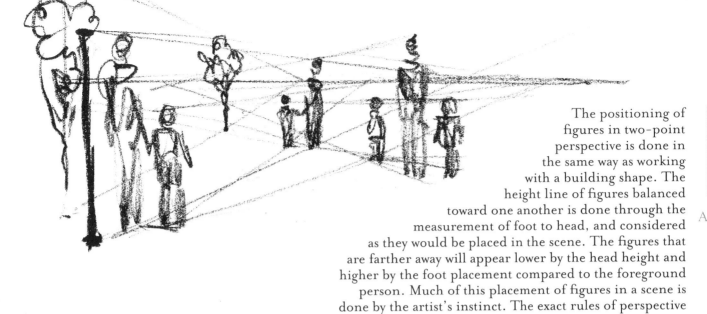

The positioning of figures in two-point perspective is done in the same way as working with a building shape. The height line of figures balanced toward one another is done through the measurement of foot to head, and considered as they would be placed in the scene. The figures that are farther away will appear lower by the head height and higher by the foot placement compared to the foreground person. Much of this placement of figures in a scene is done by the artist's instinct. The exact rules of perspective can become second nature for your eyes over time.

The heights of multiple objects and figures in a scene with two-point perspective demand attention to the position of things on the ground. Consider how a grid map like a chessboard might sit below your setting. Every item's placement will be separate on that floor pattern from one another.

A key concern in drawing a scene with two-point perspective is the potential for distortion. If the vanishing points are too close together, objects in the foreground may be distorted. The sharper the point that the triangular center point comes to, the more that the objects or bodies within that shape will need to bend and exaggerate with foreshortening. Smaller objects will appear much larger in the foreground as they relate to perspective and the creation of depth.

PUTTING "BOXES" AROUND THE FORM TO GET PERSPECTIVE

WE DRAW THINGS BY LEARNING THE PARTS AND PUTTING THEM TOGETHER IN PERSPECTIVE.

(note) get good material

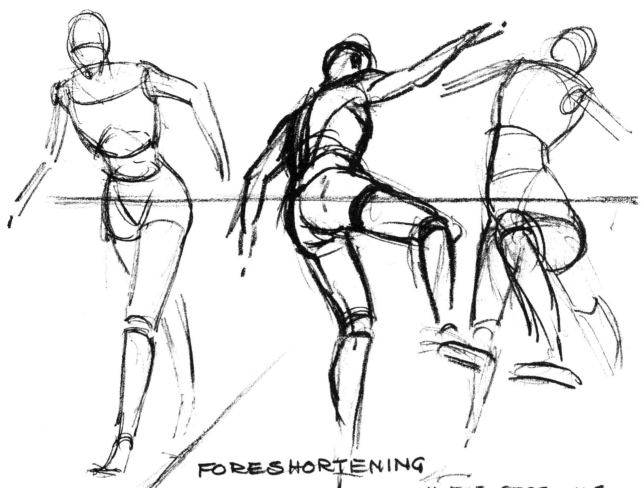

FORESHORTENING

AS WE TIP THE PARTS FORWARD OR BACK THE SECTIONS
SHOW THE CURVES A THEY DO IN A CYLINDER

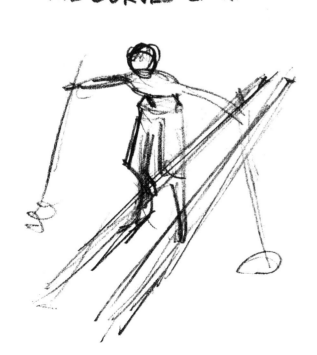

MEASUREMENT BY DIAGONALS
HORIZONTAL SPACES.

VP VP

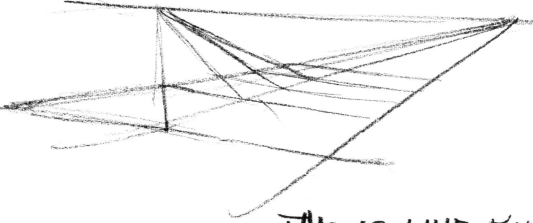

AR

Using two vanishing points on the horizon line with diagonal lines radiating from them can measure the positions for objects to fall in a horizontal space. The criss-crossing of these lines can make a dimensional grid for the setting, much like the beginning of a chessboard. This can be done for objects in the sky above the horizon line, too.

THIS IS LIKE KNOWING
THE NOTES AND BARS IN MUSIC

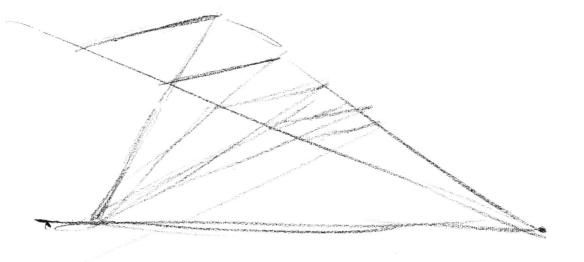

VERTICAL SPACES
IF YOU FEEL THIS IS TOO COMPLEX SKIP IT.

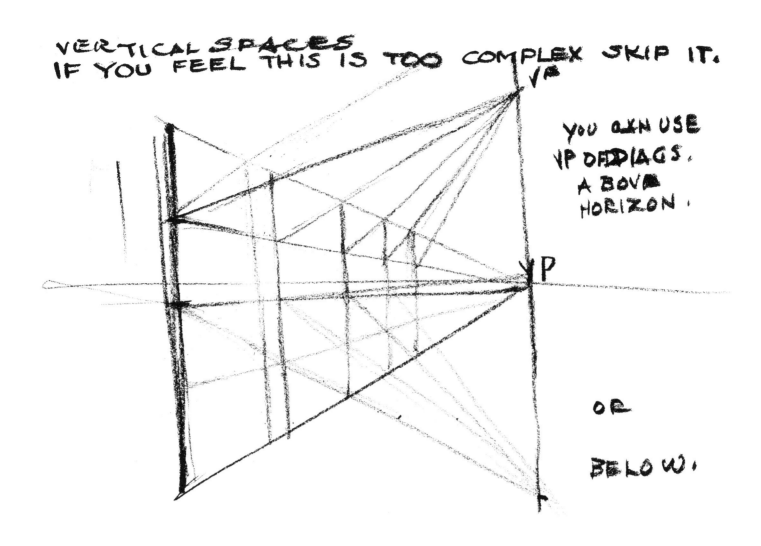

VP

YOU CAN USE
VP OF DIAGS.
ABOVE
HORIZON.

P

OR

BELOW.

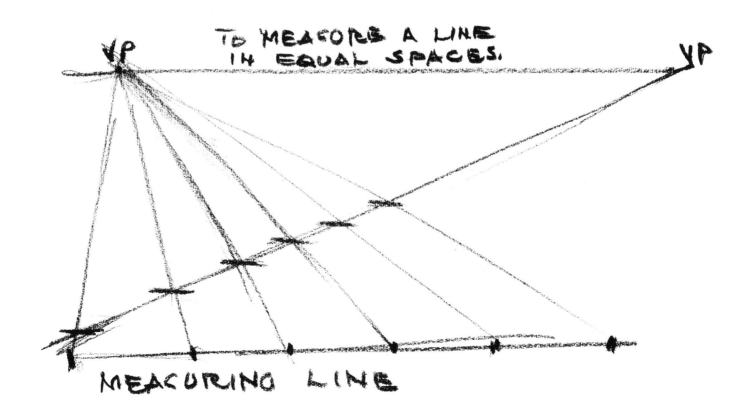

TO MEASURE A LINE
IN EQUAL SPACES.

VP

VP

MEASURING LINE

MEASUREMENT BY DIAGONALS
ODD SPACES

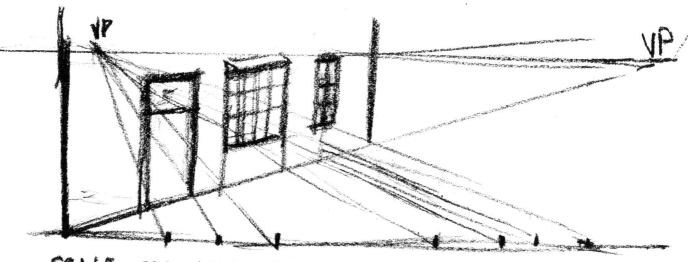

SCALE OFF MEASUREMENTS ON MEASURING LINE

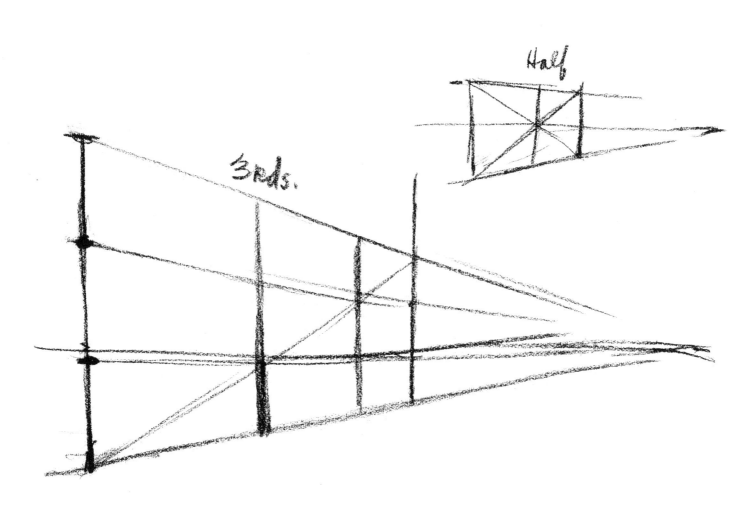

When building a three-dimensional space, diagonal lines should be used for scaling up from a measuring line. Understanding how to show a wall surface with the proper foreshortening can be measured by using diagonals that cross the shape. One can then divide objects into halves or thirds. Two intersecting diagonals will cross at the appropriate halfway line for the object in dimension. Breaking the wall into three equal segments can use a diagonal line to section the verticals into believable equal sections.

MEASUREMENT BY DIAGONALS

ODD MEASUREMENTS

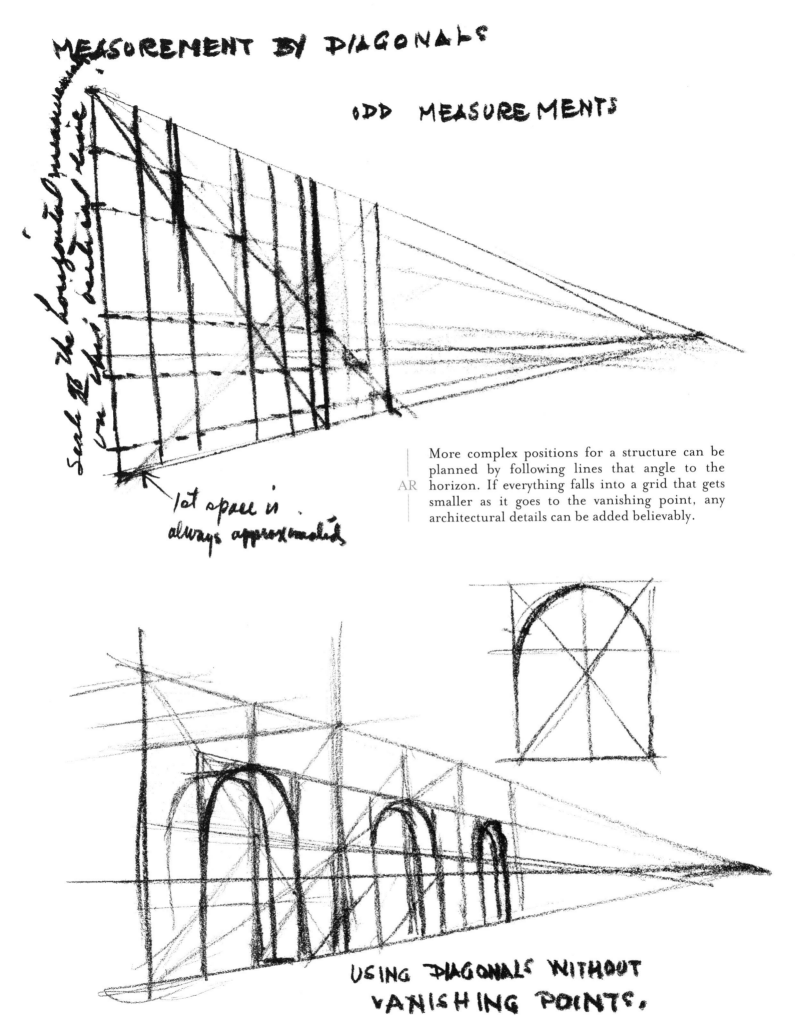

Scale to the horizontal measurement on the sheet instead of time

1st space is always approximated

More complex positions for a structure can be planned by following lines that angle to the horizon. If everything falls into a grid that gets smaller as it goes to the vanishing point, any architectural details can be added believably.

AR

USING DIAGONALS WITHOUT VANISHING POINTS.

45

A SIMPLE WAY TO GET PERSPECTIVE

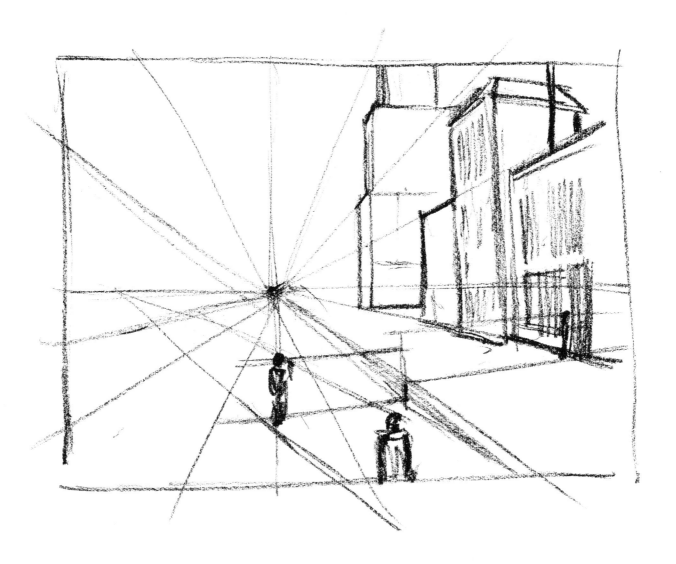

When establishing any scene, a quick use of perspective can give the setting details a truth that exists in life: all that you see is always in perspective. It's up to you to make sure your drawing shows understanding of that simple rule. When you walk down a street, be aware of your surroundings as the lines/edges of the buildings, sidewalk, and street converge toward a vanishing point. Everything rests on the horizon line.

AR

IF YOU KNOW THE PERSPECTIVE OF SPACES AND AREAS YOU CAN DRAW ANYTHING OUTDOORS OR INDOORS.

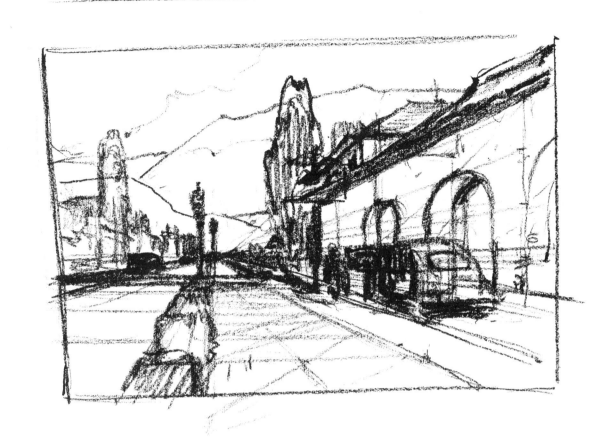

LIGHT

Few of us ever stop and examine just what light does to form until we start to draw or paint. It's really simple once the working principle is understood, but we cannot interpret form until we grasp the plan with which light works and things become visible. First, let us realize that sunlight always travels exactly halfway round an object. At the highest or nearest point on the object to the source of light, it will be brightest. When light hits a turning or rounded surface, it slides around to the halfway mark, the form getting darker as it goes. From the lightest area to the halfway mark, according to the angle of the plane as it turns away, we get what we call halftones. The more oblique the angle, the darker the halftone. For example, if we had a column or cylinder, the lightest area would be that portion which is most nearly at right angles to the source of light. The grayer portions would be the more oblique planes, each getting darker as they go around. Light can only travel in a straight line from the source of the object. Any shadow will only ease when the plane of the surface has turned to a degree equal to or beyond the line of direction of the light.

Now, the shadow always begins halfway around the basic form. Think of a sphere in light. The shortest line from the source of light to the sphere would pass through its center. Where this line hits the surface of the sphere would be the highlight.

Even though light encircles just half of a form (or whichever angle of the surface equals the direction of the light), we must remember that it may be viewed from any angle as it appears in light. We can see it from the light side with the source behind us, or from the shadow side, looking toward the light source. Or, we may see the object from any point in a circle around the object, giving us varied proportions of light and shadow. Thus, we might see no shadow if standing directly in line with the direction of light as, for example, the way a ball would look to us if we were holding a flashlight on it. If we were standing at right angles to the direction of the light, then of course we would see the object in half-light and half-shadow. The angles in between would obviously give us relative proportions of light and shadow, as, for instance, three-fourths of the way round the object from the source

of light would give us one-fourth in light and three-fourths in shadow. Nothing could be simpler than that—but we just never happened to think of it before.

So, we can go back to our basic forms as a simple exercise and light them from different directions. We must note that light always produces the highlight, then the halftone or series of them, and then the shadow, and that we can see this effect from any point in a circle around the object. We must also remember that, from any given viewpoint, all things will be lit in the same relative manner—that is, the proportion of light and shadow will be identical on all other objects seen at that moment from the same spot, unless the angle to the object is different. That means that all things must be consistent, and all seem to be lit from the same source. We therefore could not show a front lighting on one thing and a side lighting on another, when both appear in the same picture, obviously lit from the same source. I am thinking of sunlight in the above. Of course, we can have light going in all directions around a lamp or artificial source—then, naturally, things on opposite sides of the source would be lit from opposite directions. What we need to do is study the direction of the light and determine how much of the object is in light and how much is in shadow, making the lighting consistent with the truth.

If a picture or drawing is right, then it will be immediately obvious to your audience about where the light is coming from, for every angle of the light has its corresponding effect on the form. A top light, side light, three-quarter light, and a back light all produce different effects. Such an effect is what we are after, and when all is correct, identifies the surface shapes and bulk of the form. This produces mass and unity. The objects we draw take on vitality and solidity. If we do not get the shape of the light or the halftones and shadows right, the form is not correctly stated. It is through these values or tones that the form is truly identified and appears to exist. Were there no light, we could see no form.

We must take into consideration the different kinds of light. Sunlight produces definite lights, halftones and shadows. But, suppose we have a diffused light, like the light from the sky alone, on a cloudy day. There

is still light, halftone, and shadow, but they are not so separate and distinct. All seem to be diffused so that the lights, halftones, and shadows seem to soften and merge or melt together. But, again, this is an effect, and if we understand the reason for that effect and capture it, our subject still appears solid and seems to exist just as much. The real difference between diffused light and sunlight is that the former does not cast definite or defined shadows, or what we call 'cast shadows'. That means shadows 'cast' to another plane—for example, the shadow of a figure cast on the ground by sunlight. The diffused light of a cloudy day casts no evident shadow, but the under-planes are dark. The forms in diffused light take on a sculptured effect: that is, the shapes and forms are modeled on the surface by light and dark, but there is no single direction of the light source. It is lit more or less evenly all the way round, instead of halfway round (as in direct light).

Finally, there is reflected light, or light that is bounced back from all lit objects. This makes the part where the shadow begins the darkest part on rounded forms, getting lightest in the middle part of the shadow area. On flat planes, a cast shadow is more or less an even tone. Study the following drawings so that these things become clear.

LIGHT.

There will be no shadow unless the form turns to a degree equal to the direction of the light.

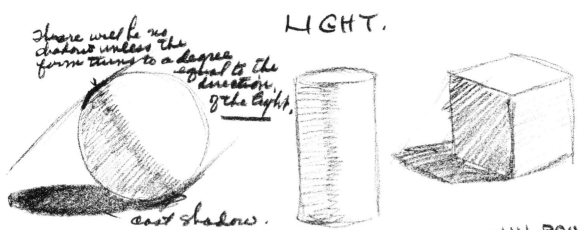

cast shadow.

BRIGHT, DIRECT LIGHT CAN ONLY GO HALFWAY ROUND A SOLID OBJECT. BUT WE MAY VIEW IT FROM ANY POINT IN A CIRCLE AROUND THE OBJECT

THE SMALL SPHERES SHOW HOW IT APPEARS AT DIFFERENT POINTS AROUND THE CIRCLE

outer balls indicate what the center ball would look like from each spot in the circle around it.

(THE BALL LIGHTED FROM THE UPPER RIGT SIDE)

PEOPLE STANDING AROUND THE BALL WOULD EACH SEE IT DIFFERENTLY. SO, VIEW POINT IN RELATION TO THE LIGHT SOURCE ALWAYS DETERMINES THE EFFECT OF LIGHT AND SHADOW THE MOON IS MUCH LIKE THIS, GOING AROUND THE EARTH.

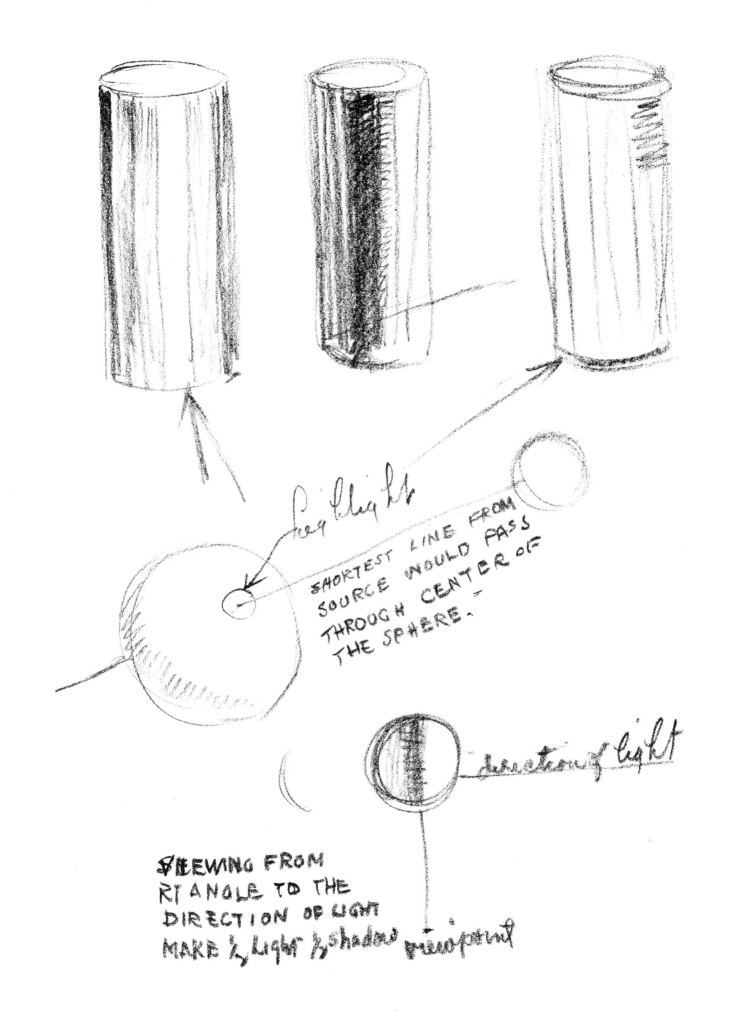

highlights

SHORTEST LINE FROM
SOURCE WOULD PASS
THROUGH CENTER OF
THE SPHERE.

direction of light

VIEWING FROM
RT ANGLE TO THE
DIRECTION OF LIGHT
MAKE ½ LIGHT ½ SHADOW viewpoint

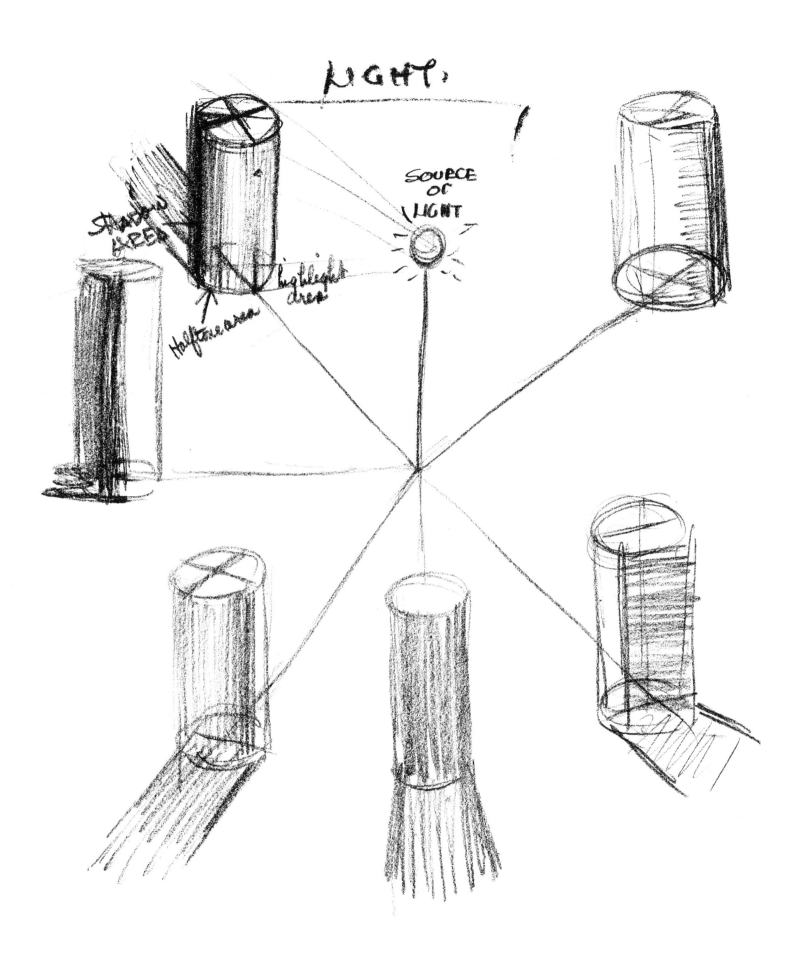

LIGHT.

SOURCE OF LIGHT

SHADOW AREA

Halftone area

highlight area

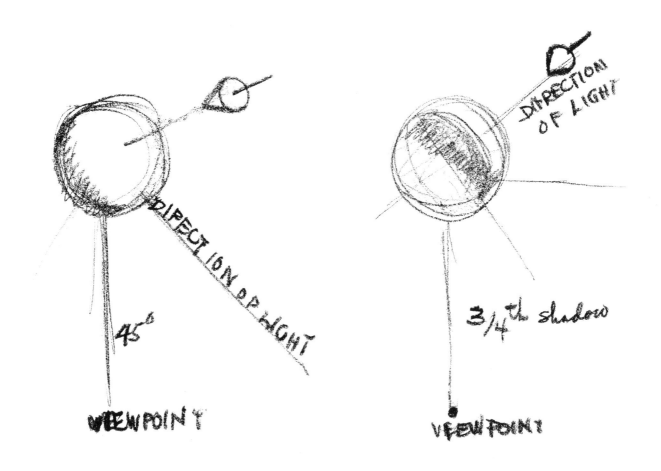

DIRECTION OF LIGHT

45° DIRECTION OF LIGHT

VIEWPOINT

3/4th shadow

VIEW POINT

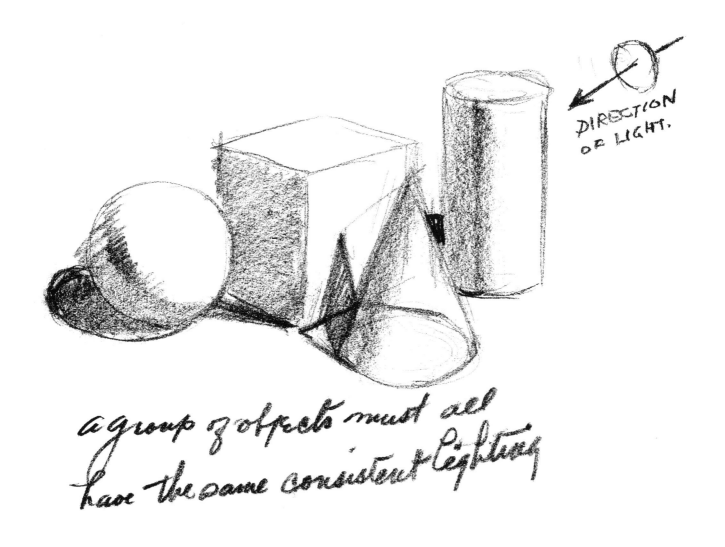

DIRECTION OF LIGHT.

a group of objects must all
have the same consistent lighting

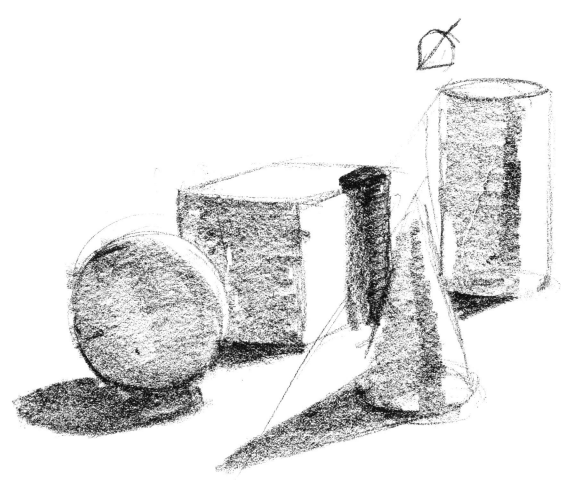

EVERY ANGLE OF LIGHT PRODUCES A DIFFERENT ASPECT
EVERY VIEWPOINT PRODUCES A DIFFERENT EFFECT.

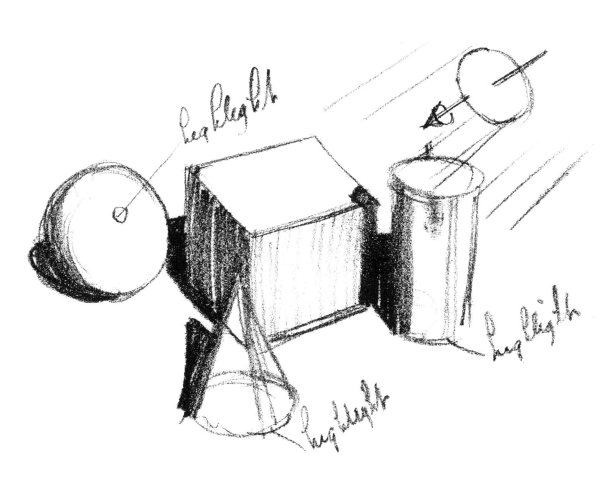

COMPARISON OF DIRECT AND DIFFUSED LIGHT

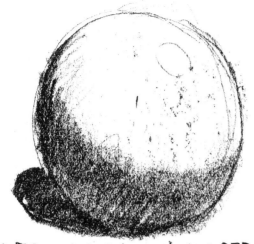

DIRECT LIGHT PRODUCES
DEFINED LIGHT AND SHADOW
AND A CAST SHADOW

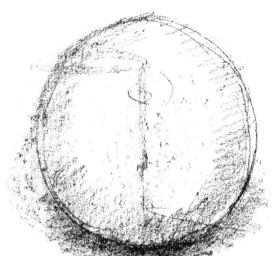

DIFFUSED LIGHT PRODUCES
SOFT HALFTONES AND
INDEFINITE SHADOW.

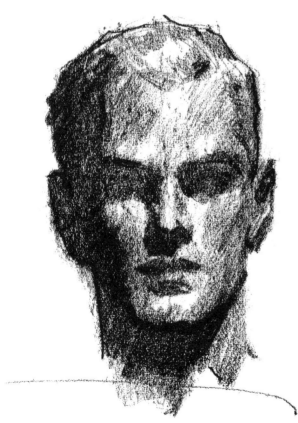

DIRECT LIGHT

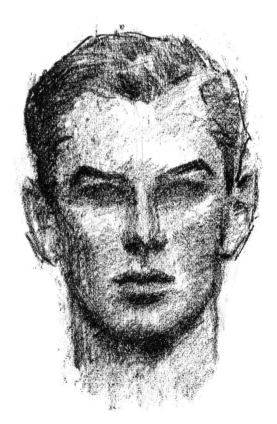

DIFFUSED LIGHT

THE KINDS OF TONES OR VALUES WE SEE IS THE EFFECT OF THE LIGHT ON THE FORM

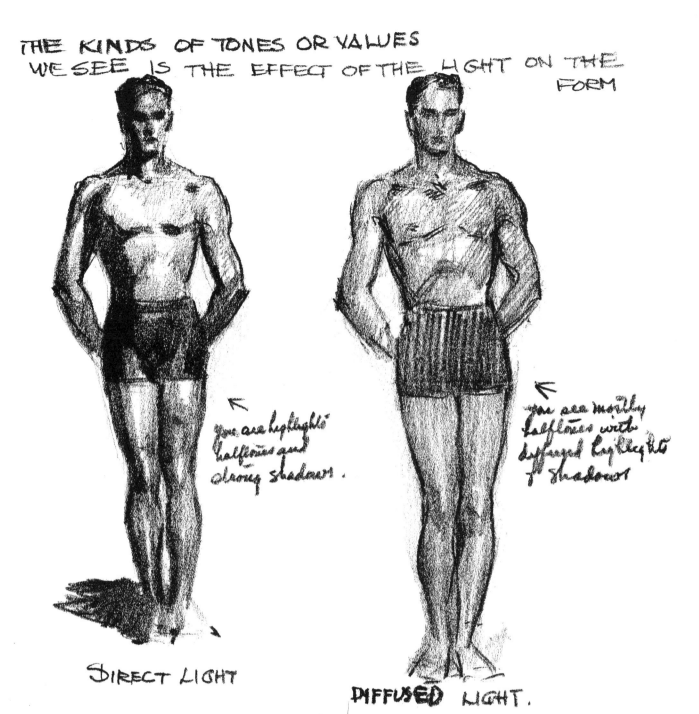

← you are highlights halftones and strong shadows.

← you see mostly halftones with diffused highlights & shadows

DIRECT LIGHT

DIFFUSED LIGHT.

EVERY SUBJECT IN DRAWING FROM LIFE HAS IT'S SEPARATE AND INDIVIDUAL SET OF CONDITIONS WHAT YOU MUST LEARN IS TO ANALYZE AND UNDERSTAND THE CONDITIONS. YOUR LIGHTING IS THE FIRST AND FOREMOST PROBLEM FOR IN THE LIGHTING WE PRODUCE THE FORM. THEN WE STUDY THE FORMS - FIRST AS BASIC FORM, THEN AS SURFACE OR INCIDENTAL FORM. WE MUST GET THE PRO- PORTIONS, THE PERSPECTIVE, AND THE TONAL EFFECT OF LIGHT ON THE FORMS. BY THESE WE LIFT OUR- SELVES OUT OF THE MEDIOCRE GROUPS.

GETTING

OUT

THE HEAD

Now folks, here's what we have been waiting for. Let's cut loose and have some real fun! You know, I really hated to drag you through all that deep stuff about perspective, but it's really like those darn notes in music: sooner or later, you're going to have to get them if you really intend to go to bat with music. We can't draw too well or hope to ever sell our work without perspective. But there is a sort of close up perspective that you can feel without going halfway across the room to find your vanishing point. If you are serious, you better get that little book I mentioned, and stay with it until you understand it.

Perspective is really about putting things behind each other, or making them appear to go back into space. But a face doesn't go back very far, and so long as we can tip it and turn it or make it do what we want it to, you can still have a lot of fun with drawing.

To get there, we have to break the head down into parts, and then build the face on a middle line together with the construction lines that go around the head. The features must fall into place, otherwise the face is going to look more like a moron or an imbecile. It isn't going to

be good or even funny if you can't draw the darn thing.

If you are serious about drawing the figure, maybe my earlier book *Figure Drawing For All It's Worth* will help you. But if you will be satisfied drawing a pretty fair figure without knowing the basic anatomy, then this book should do the trick.

Knowing the parts, or sensing the forms and building them up is the whole idea of good drawing and even good art. We can treat the parts very simply, even grotesquely at first, until you gradually get the working basis. We are never going to get anywhere just tracing around contours. If you want to do that, get a projector and trace your copy. Some do that. But they are not very creative, and do not get the fun out of it. They do it as very serious business, for the simple reason that they have never really learned to draw. Until a man thinks in terms of volumes and solids, his work will have a certain characterless map-like effect, and he won't know what is missing. Building your shapes allows you to draw purely from the imagination, and it will still look good because it has solidity.

THE SPHERE IS THE BASIS

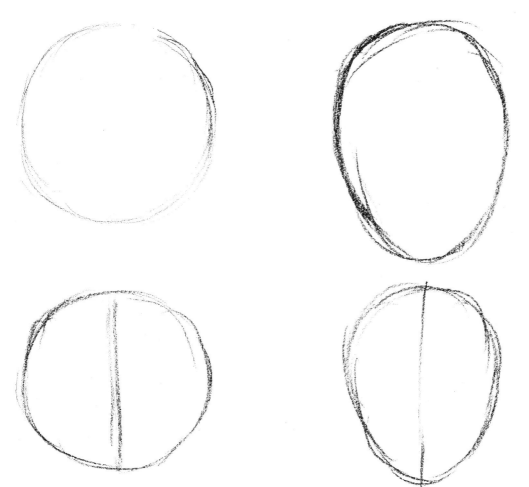

WE GIVE EVERY BASIC FORM A MIDDLE LINE
UP AND DOWN AND ONE ACROSS.

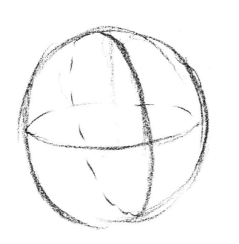
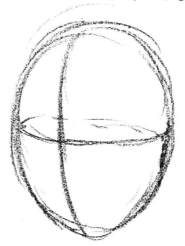

NOW WATCH WHAT WE DO

TO THE EGG AND SPHERE WE ATTACH SHAPES

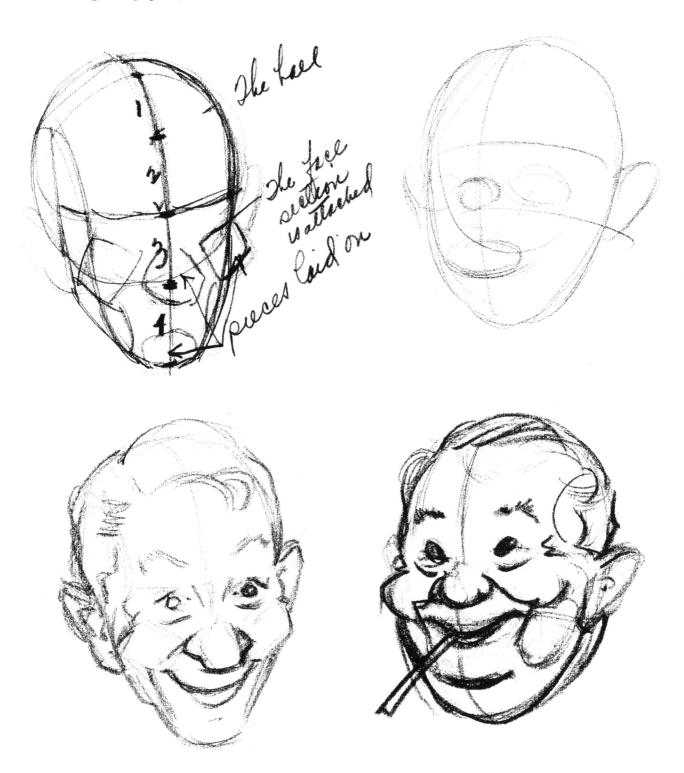

Breaking down face shapes in a caricatured form is a helpful first step to understanding how to balance them on the egg and sphere shapes of the human head. As you experiment with dimension to these shapes—the nose, eyes, ears, and such—think of them as building blocks you must lay on at their level. Think of the face in sections to help with placement. Doing this will also help create an exaggerated expression.

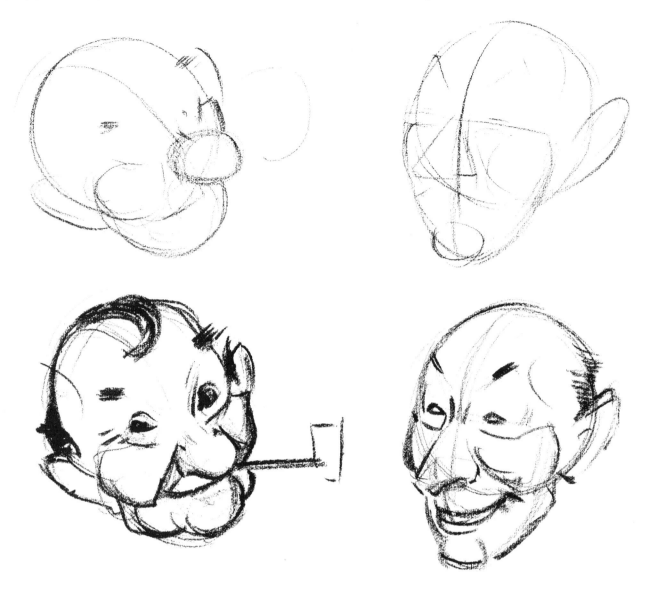

Knowing how to turn features in three-quarter perspective can be challenging, so there is only trial and error to get it right. Try treating features as simple shapes: circles, cones, triangles, etc., to help understand that all shapes have a simple geometric quality. Drawing the forms with greater detail and curvature is the next step to solidifying the drawing. The shapes or facial details will be closer together or narrower on the farther side of the head.

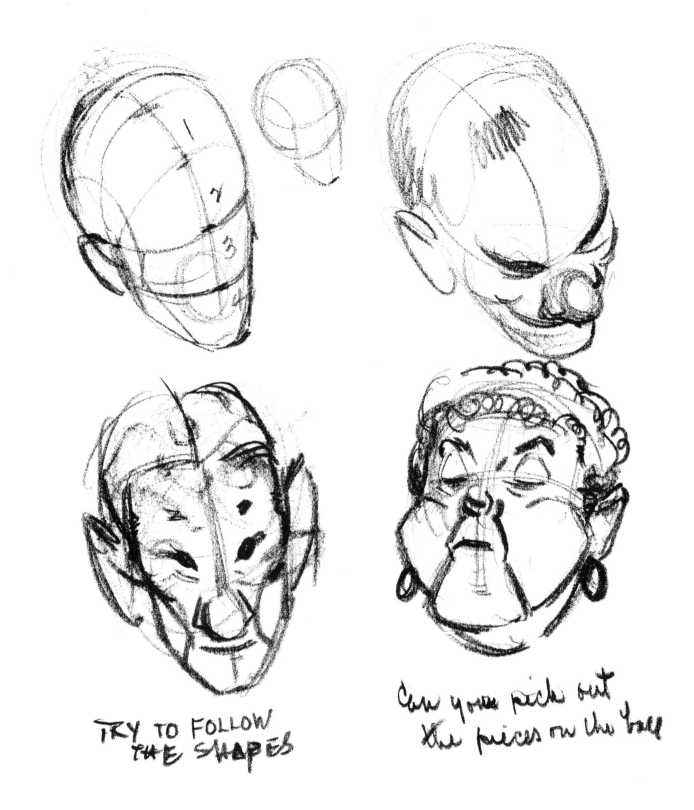

TRY TO FOLLOW
THE SHAPES

Can you pick out
the pieces on the ball

Studying the egg/sphere shape from extreme angles can benefit your greater understanding of how the head works. Remember that no one sees just one view of the head, depending on the eye level or the tilt of the head attached to a person's neck. We see all objects from multiple angles. Why not get it into your head how many ways one can draw the human head?

AR

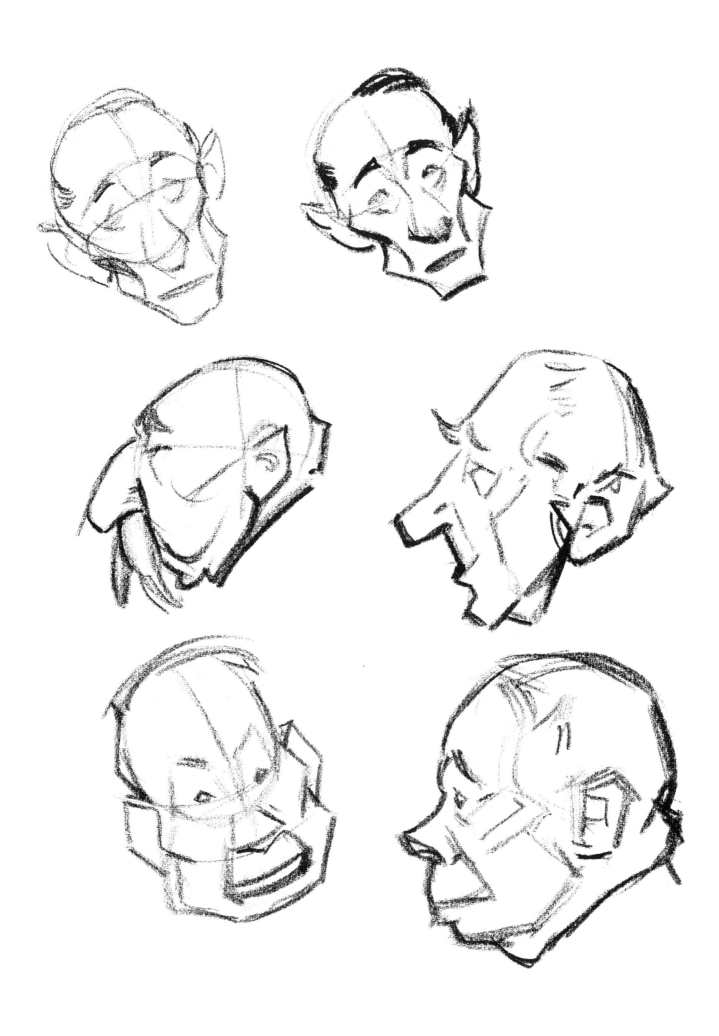

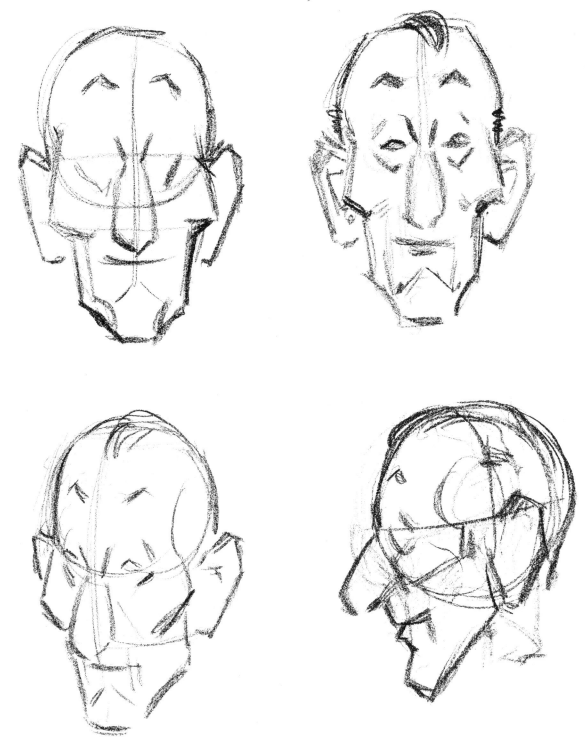

Once you begin to sculpt the head from its basic forms, you begin to truly know how to position the head the way you would like. Drawing life relies upon more than a tracing of contours but an intuitive understanding of how objects exist in three-dimensional space. Using caricatured, exaggerated forms to interpret a face can help with this.

AR

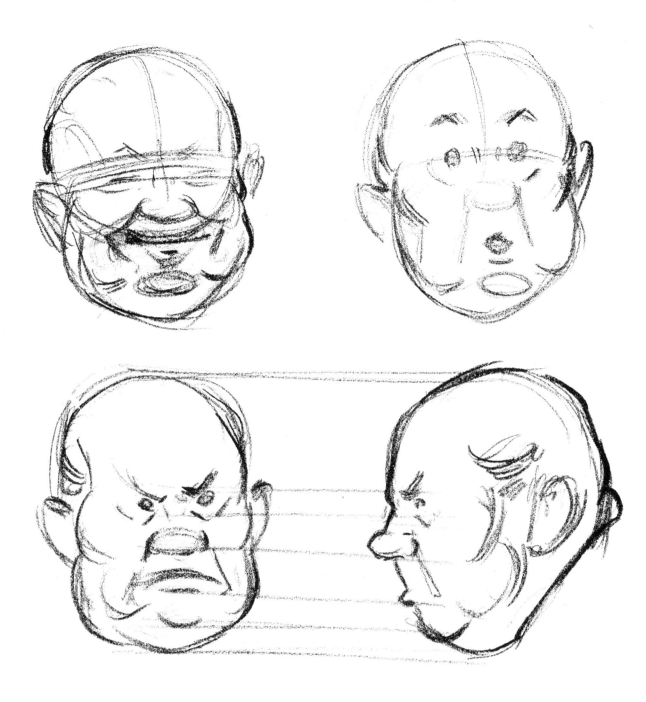

Reducing features to a more cartoonish shape can guide the skeleton of different facial expressions. To make an expression, we must show how the closest shapes bend to that look. A smiling, surprised, or scowling face has the elements of eyes, nose, and mouth all working together to effect that identifiable look. Wrinkles and creases also help to create the age and emotion you want the expression to create.

AR

67

VARIATIONS OF THE SAME BASIC STRUCTURE

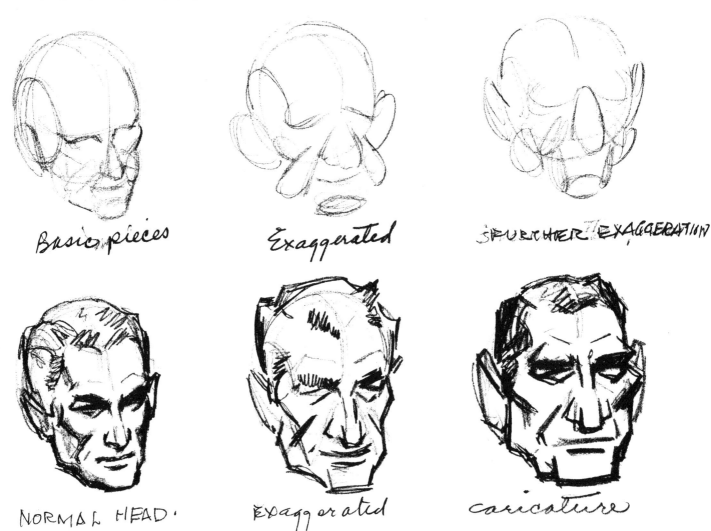

Basic pieces

Exaggerated

FRURTHER EXAGGERATION

NORMAL HEAD.

Exaggerated

caricature

Here we see examples of how exaggerated forms can be relatable to normal head structure. In some ways, the time spent with caricature is the best way to gradually ease toward a comfortable, informed view of drawing realistic life. This approach doesn't demand that you be a cartoonist. You simply need to apply the principles of facial conversion to physical extremes so that the unique turns in every shape become identifiable to you.

AR

EXAGGERATION

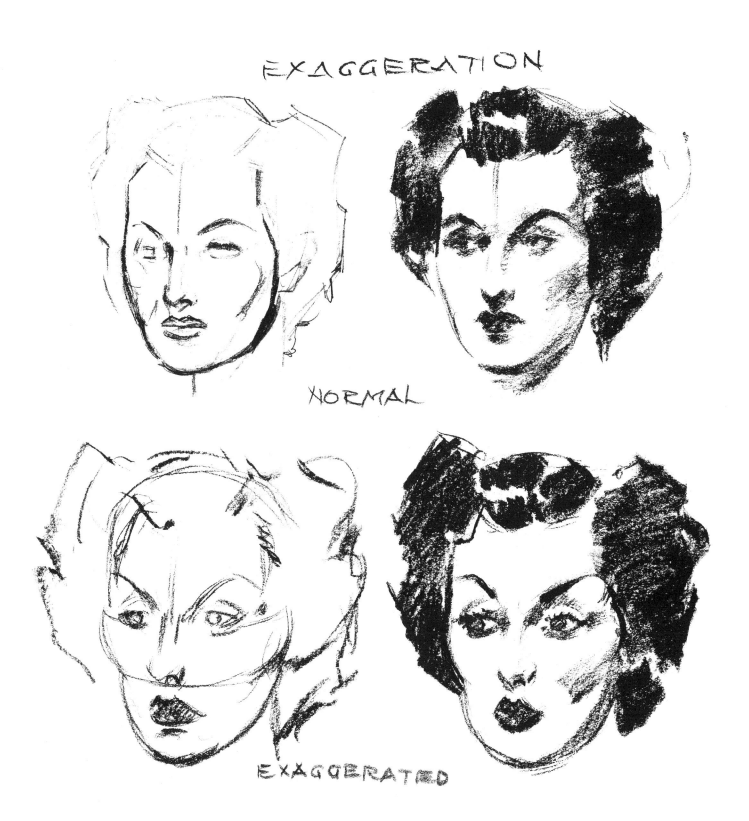

NORMAL

EXAGGERATED

AR Once you have developed some ease with seeing the ways to exaggerate life, you can begin scaling that back to realism with the application of shading. The way that light can define a more realistic solidity can be used on a normal or exaggerated structure in the same way. Shadows and the gradual turn of form will grant volume and mass as well as define expression and mood.

THE CHARACTER IS IN THE FORMS OF THE SKULL PLUS THE FLESHY PIECES ATTACHED

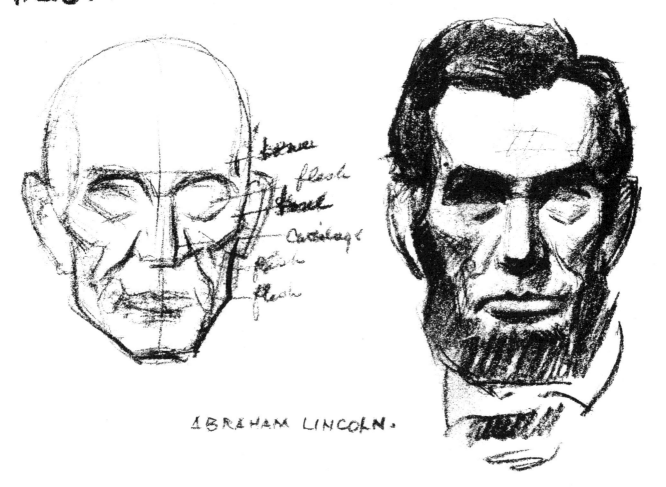

ABRAHAM LINCOLN.

A famous face of distinctive character is a great tool to use for study. Here we find the subtle exaggerations at play in the features. It's important to break down our idealistic perceptions of the human head into the complexity that life has to offer. We must identify the fleshy pieces to attach to the skull, building out to the exact form that matches the subject and can identify a likeness.

STUDY THE SKULL SHAPE THEN THE FLESH.

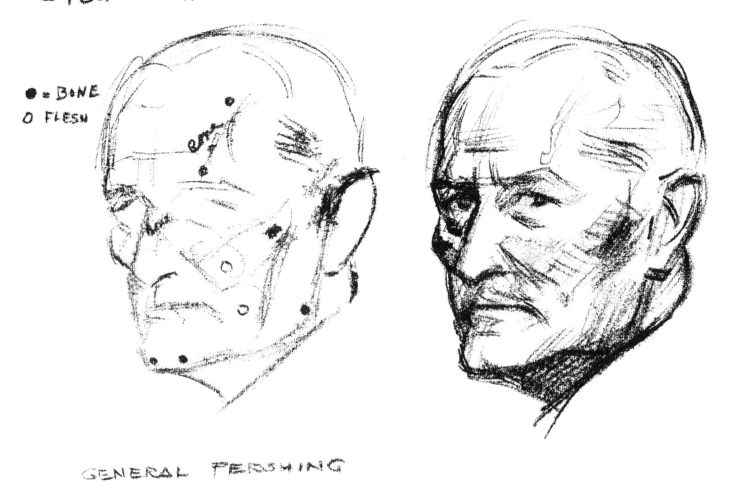

● = BONE
O FLESH

GENERAL PERSHING

First, you must craft a geometric simplification of the face you see. Within that shape are differences of underlying bone to flesh tissue. The skull is the stage upon which a great variety of set dressing can drape. The older your subject, the more folds and flowing flesh may pull away from the core structure.

AR

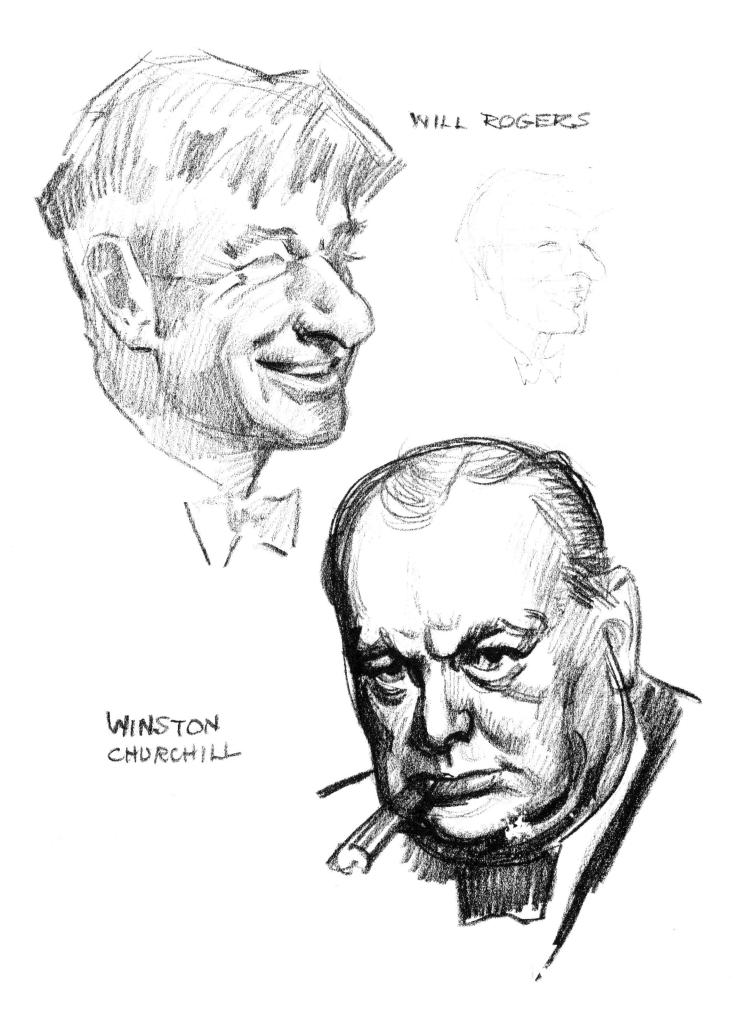

WILL ROGERS

WINSTON
CHURCHILL

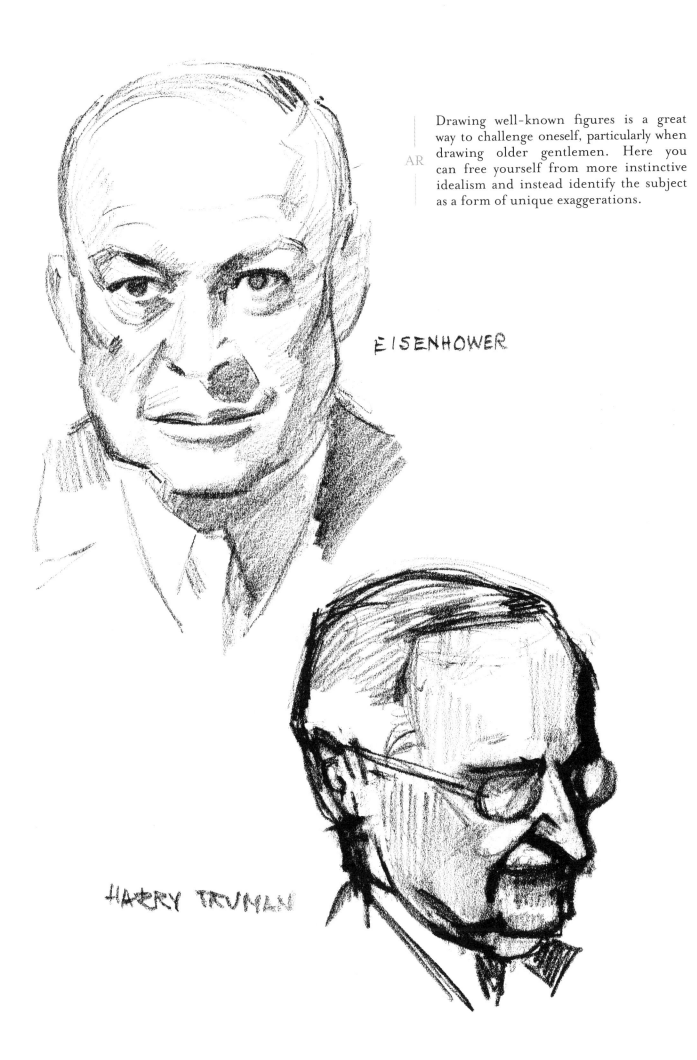

Drawing well-known figures is a great way to challenge oneself, particularly when drawing older gentlemen. Here you can free yourself from more instinctive idealism and instead identify the subject as a form of unique exaggerations.

EISENHOWER

HARRY TRUMAN

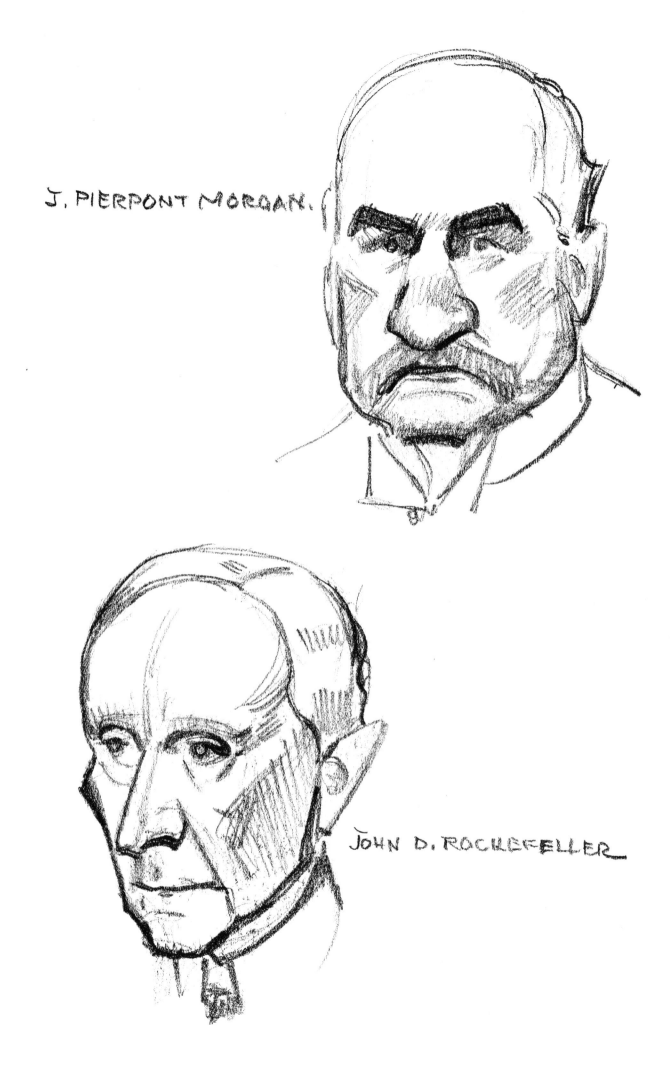

J. PIERPONT MORGAN.

JOHN D. ROCKEFELLER

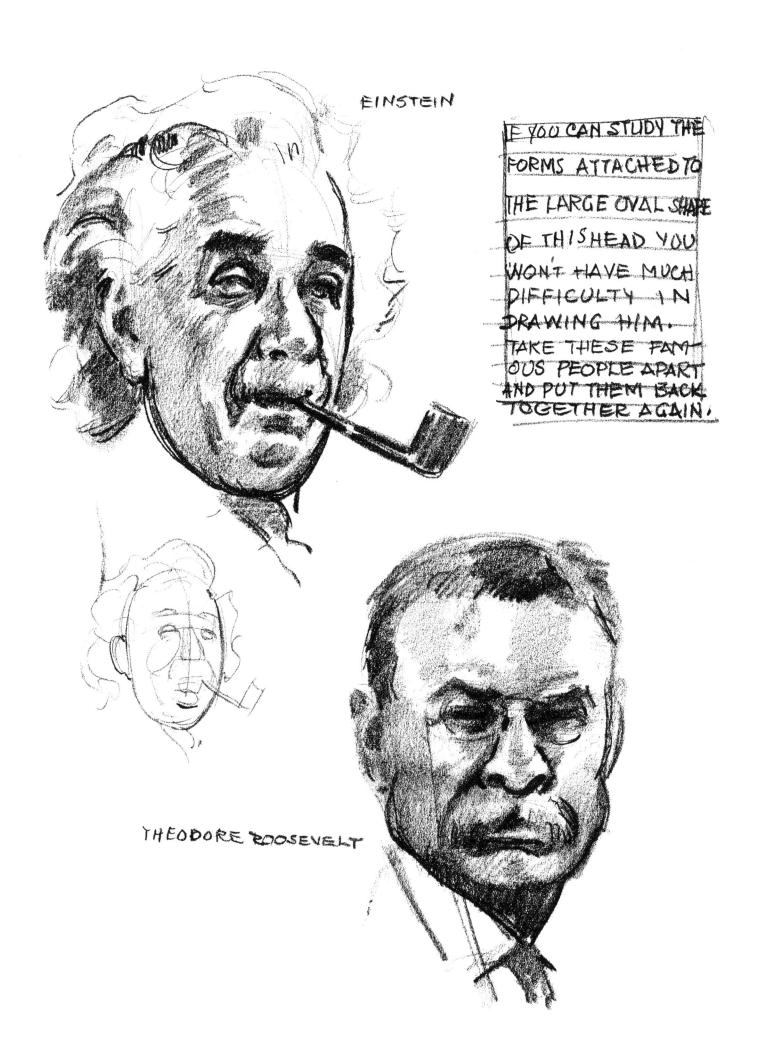

EINSTEIN

IF YOU CAN STUDY THE FORMS ATTACHED TO THE LARGE OVAL SHAPE OF THIS HEAD YOU WON'T HAVE MUCH DIFFICULTY IN DRAWING HIM. TAKE THESE FAMOUS PEOPLE APART AND PUT THEM BACK TOGETHER AGAIN.

THEODORE ROOSEVELT

The points where one can find caricature are not so boldly removed from the real person, which can be a refreshing moment. Historical figures often grant that feeling.

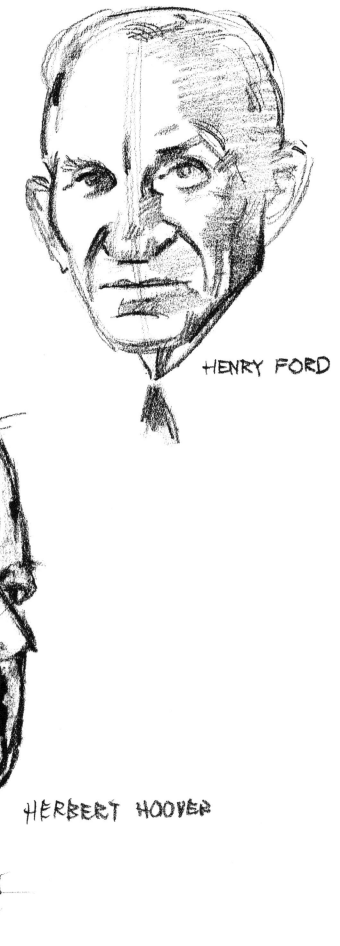

HENRY FORD

HERBERT HOOVER

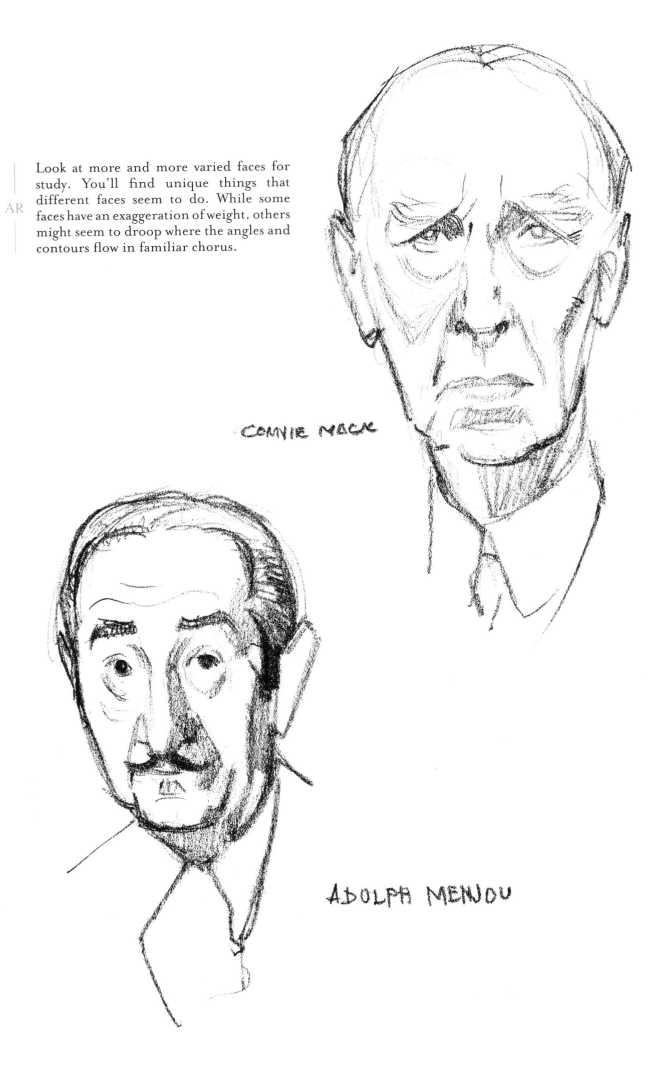

Look at more and more varied faces for study. You'll find unique things that different faces seem to do. While some faces have an exaggeration of weight, others might seem to droop where the angles and contours flow in familiar chorus.

CONNIE MACK

ADOLPH MENJOU

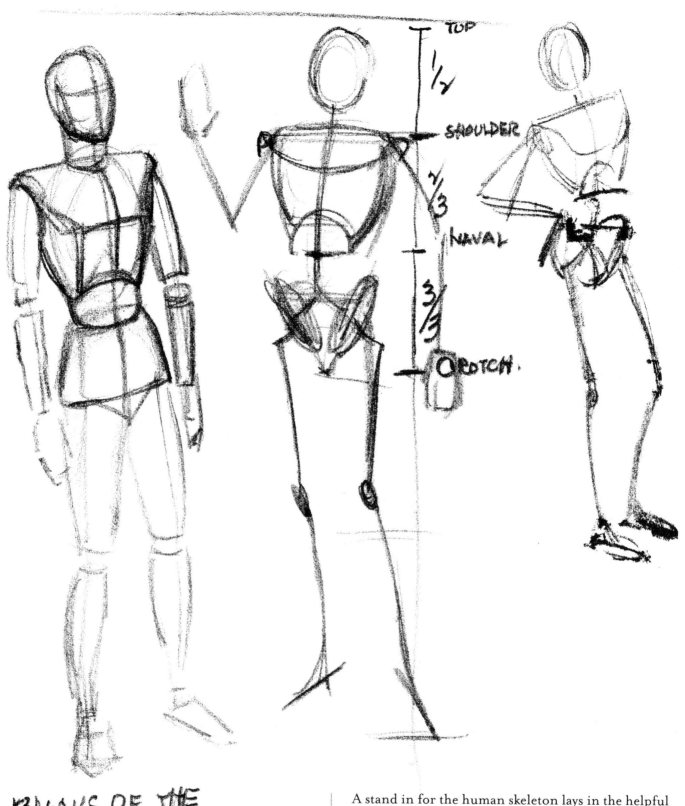

TOP

1/7

SHOULDER

2/3

NAVAL

3/3

CROTCH.

BLOCKS OF THE MANNIKIN.

A stand in for the human skeleton lays in the helpful form of the mannikin. Its separate wooden forms follow the natural pivot points in our bodies, making it a valuable tool for drawing the human figure.

AR

THE FIGURE

The figure is no different than the other things we draw. While it is changeable and has elasticity, we can only draw it as it appears in a single instant. Therefore, we must approach the form as we would any other solid or groups of solids. We can, without knowing the anatomical structure of the skeleton, draw basic middle lines through the main bulk and parts on which to build the solid forms. We therefore build the balls and cylinders, the blocks and angles as they appear to us, in a simplified version of the surface appearance. You can invent your own basic forms, so long as they give you the shapes you want, or result in the character you are after. For that reason, just a ball will do for the chest or torso, or a lock or girdle for the hips and buttocks.

If you wish, invest in one of the mannikins as advertised in the *Artist Magazine*. This 'Oscar' will be invaluable to you in creating figures of your own. Even in this small mannikin, here is the effect of perspective, for it will appear differently at different degrees, above or below your own eye level. The sections will be a modification of balls and cylinders, just the things we have been talking about. You can set him into action poses to a remarkable degree, making a good basic interpretation of the action of the live figure.

Some of the following drawings will be treated as simple comic drawings, while others will be more lifelike. We have talked of light and shadow, and so we shall endeavor to get some of these solid effects into our comic interpretations.

The novice can only guess at the amount of real fun there is in creating these little characters. Some of them take on surprising reality. But, we simply cannot draw them until we have understood the basic approach. Some artists can only copy other artists or photos. Some can make a creditable copy of things in real life. But these men seem to be wholly dependent upon having something in front of them to draw. They do not build, and therefore cannot create forms of their own. You may be sure that it is in the creative part of drawing that the real fun lies. Then again, if you draw by building the forms, all form seems to take on new meaning, becomes understandable and clear—and becomes much easier to draw.

The reason that the novice instinctively tries to draw the finished contour first is that, to him, the contour is all there is. Contours started with the cave man. We all see contours and edges long before we have started with the cave man. We all see contours and edges long before we have any conception of bulk, or any idea of how to represent it. Of course, even in drawing simplified forms, or basic forms, we still must set down contours. But we are starting with simple contours, not the exact and complicated edges, until we are ready for them.

To try to draw a profile down the complete side of a figure or object is next to impossible, getting every hump and bump proportionate. Yet, nine out of ten amateurs try to do just that. No wonder they find drawing difficult—it would be extremely difficult for even the professional artist.

It is of surprising value to the young artist or novice to feel around with modeling clay. He immediately begins to sense the mass and bulk of things. It is easier then for him to draw such bulk later on. The armature or frame on which to model a figure in clay can be bought, all set up on a revolving stand. Having this and one of those 'Oscars', you will know more about drawing in a few weeks than many will know in a lifetime.

I personally like to think of art as an interpretation of form, in light, action, value, and color. To this is coupled an idea or function. This will serve as a basis to all art, and is the key to what is wrong with a great deal of it. It generally falls down in one department or another. Of course, it's a big order, and not nearly so simple as it sounds, but at least it gives us a clear understanding of what we are trying to do.

EXAGGERATION OF THE MANNIKIN

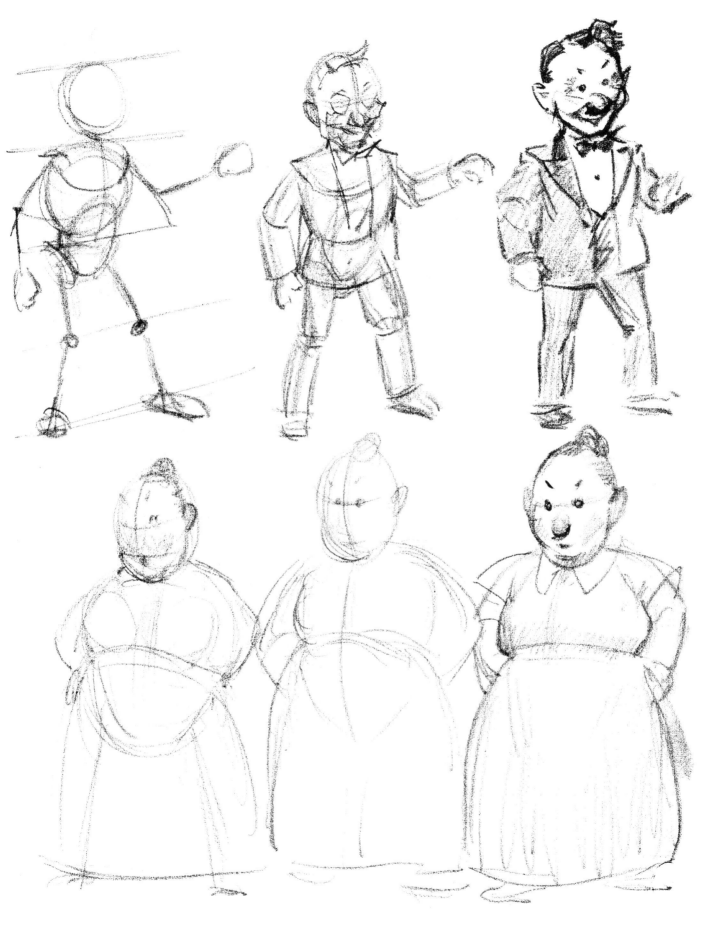

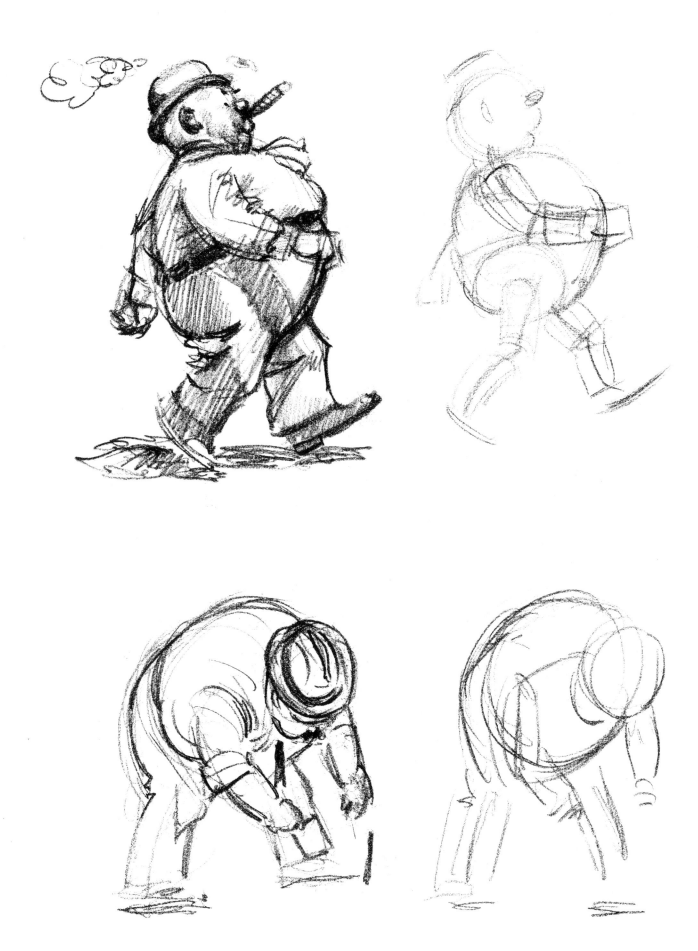

Seen here, the caricatured subject still has a basic mannikin form matching his every limb, revealing how the underlying structure breaks down. All that is added is more 'meat' onto the structure of the form.

82

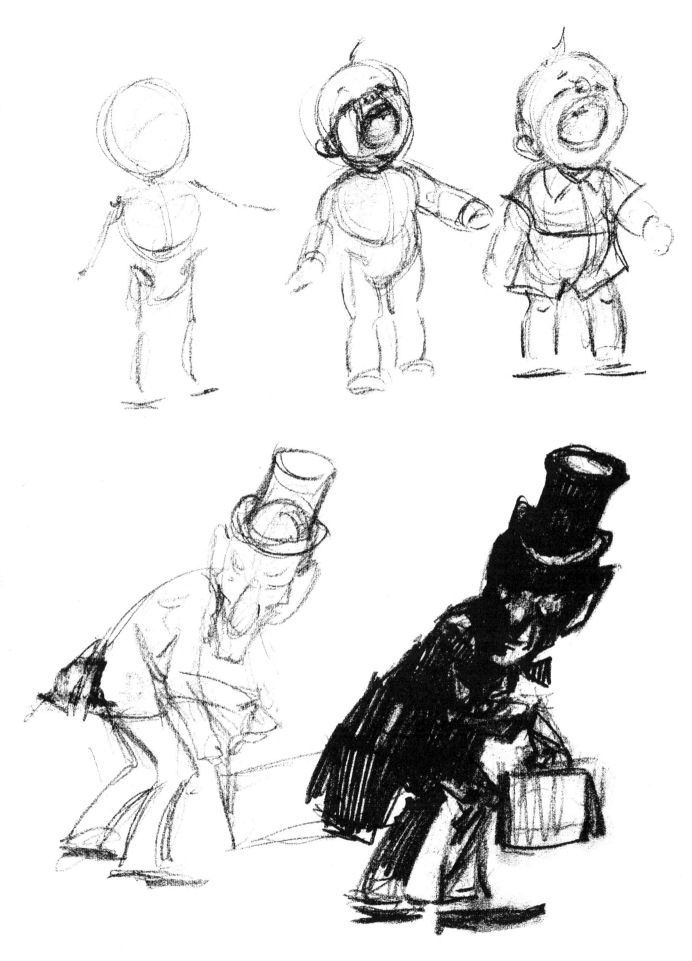

To best construct any figurative drawing, the simple volume and mass of the mannikin form should be built upon. Complex exaggeration can be applied within the balls' and cylinders' sizes and shapes, which work together and guide the final outcome.

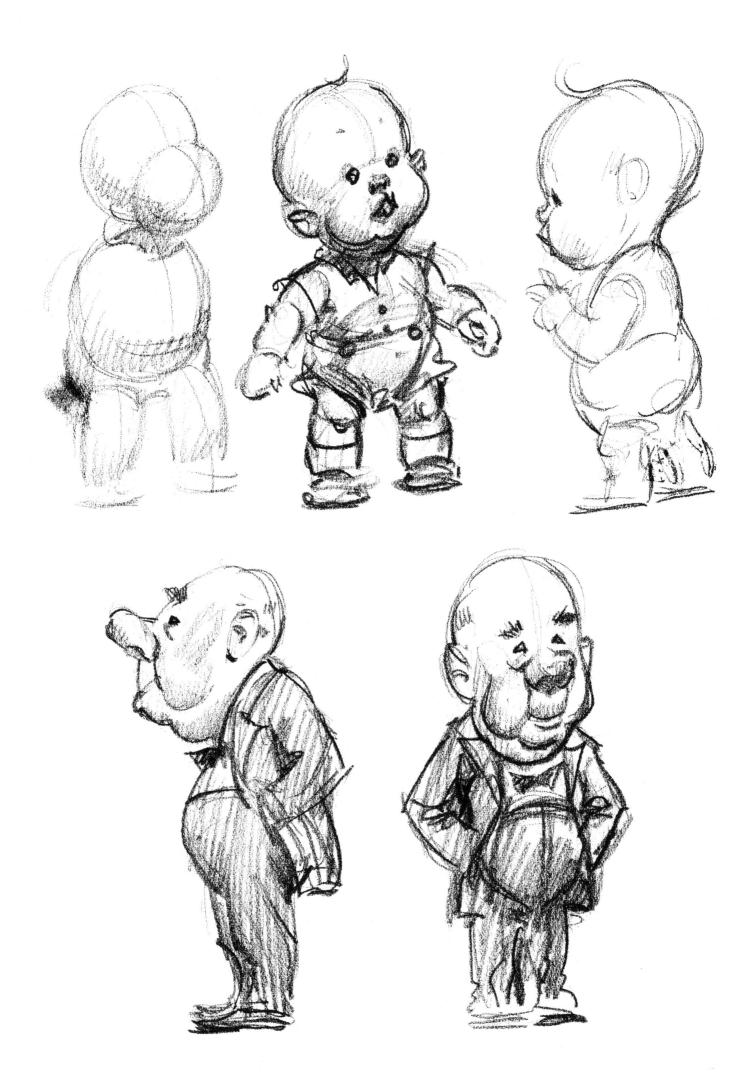

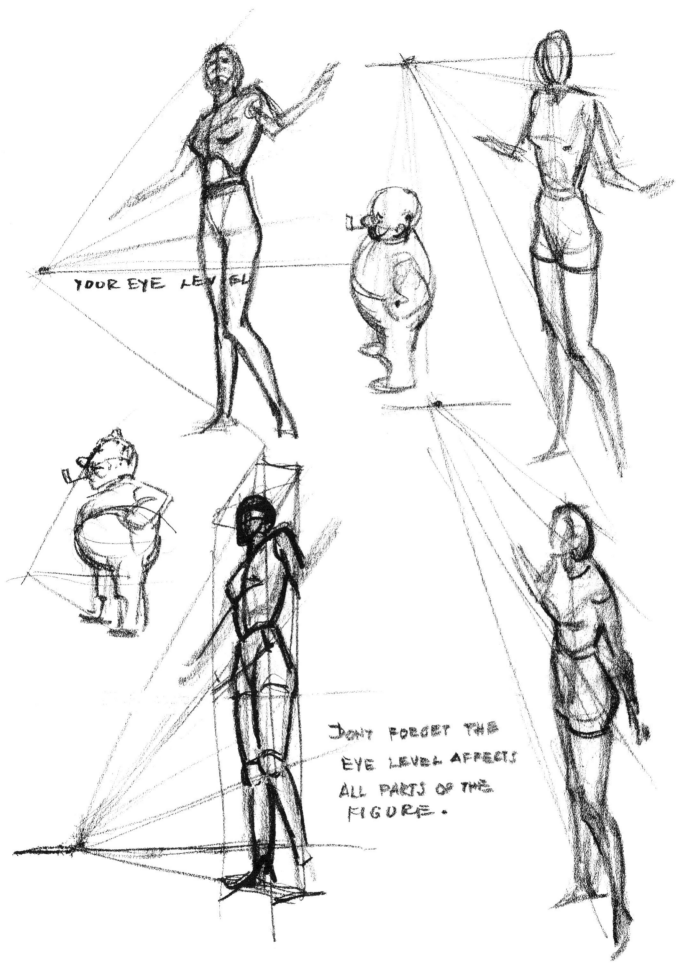

YOUR EYE LEVEL

DON'T FORGET THE
EYE LEVEL AFFECTS
ALL PARTS OF THE
FIGURE.

As we begin to understand how to use the basic figure shape, the principles of perspective are never far away. The angle from which we view a body is affected by how it relates to the world around it. The perspective in which the figure is seen in relationship to the horizon line should always be considered.

Some visitors from "FUN WITH A PENCIL".
(new drawings)
rendered in
light + shadow)

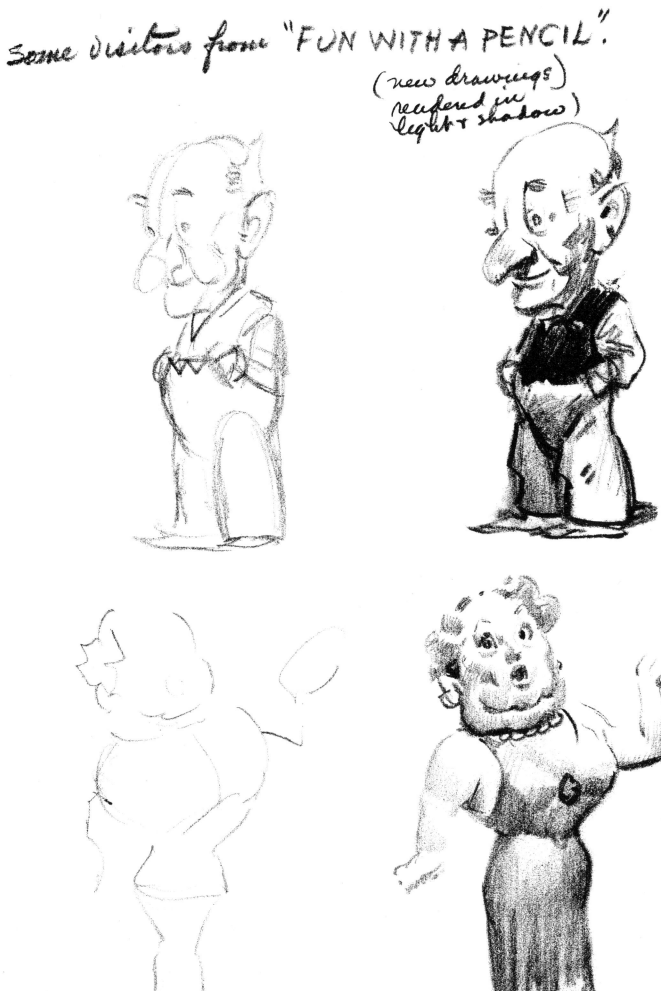

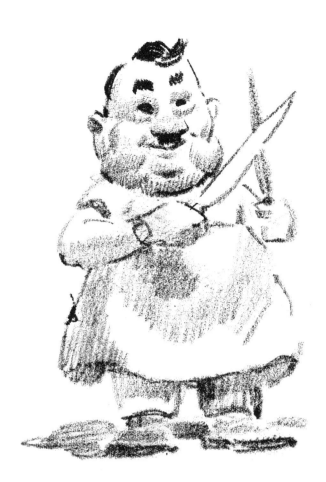

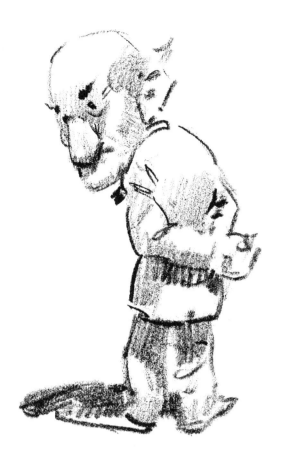

will pick 2 others

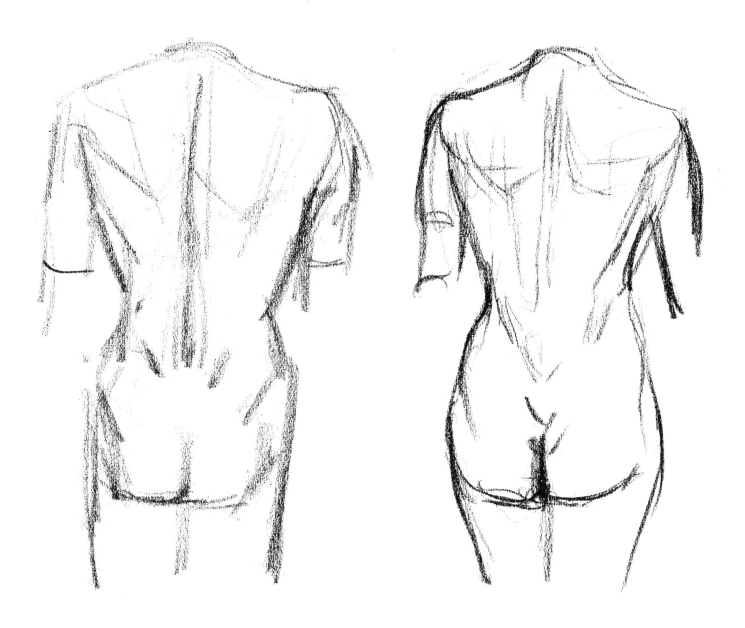

The initial construction of the torso sets the shapes in place and allows lighting to grant dimension, volume, and life. Seeing the human body as an increasingly complex collection of cylinders and spheres is a good way to understand how light will fall across it. The shadows will fall across the body shape with no different effect than how they occurred on the sphere.

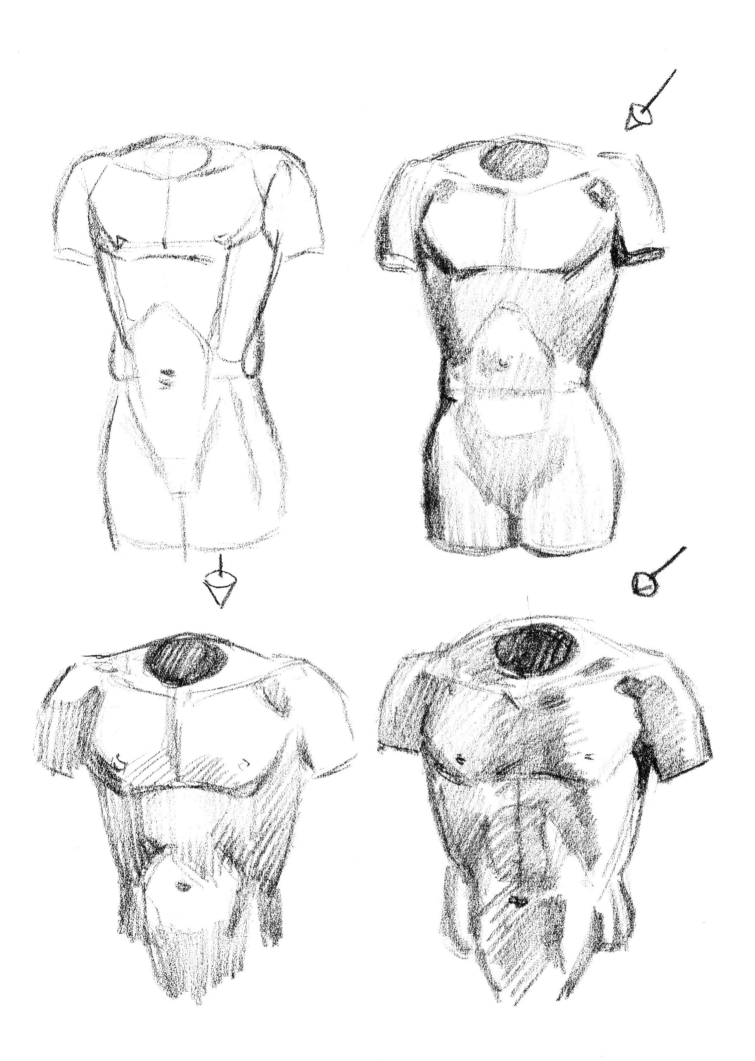

DRAWINGS FROM AN "OSCAR"

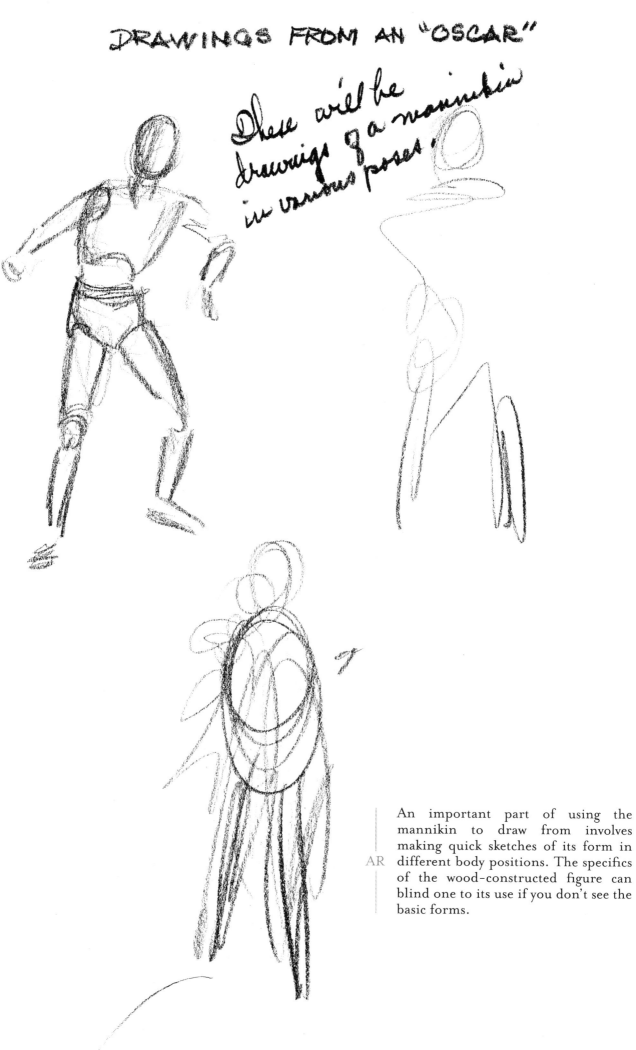

These will be drawings of a mannikin in various poses.

An important part of using the mannikin to draw from involves making quick sketches of its form in different body positions. The specifics of the wood-constructed figure can blind one to its use if you don't see the basic forms.

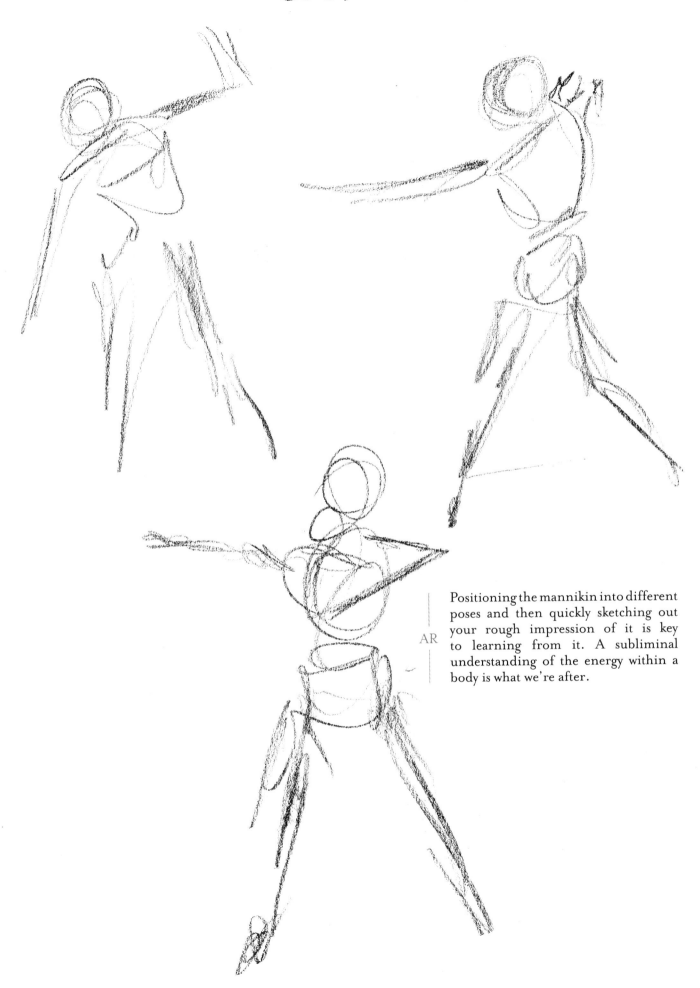

Positioning the mannikin into different poses and then quickly sketching out your rough impression of it is key to learning from it. A subliminal understanding of the energy within a body is what we're after.

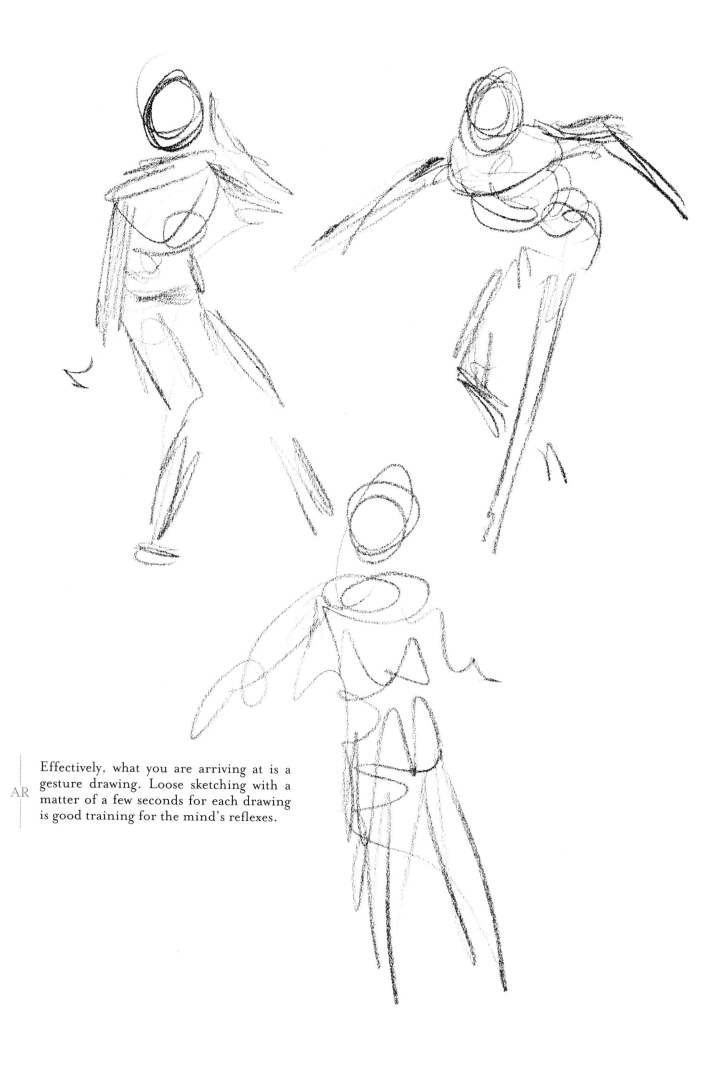

Effectively, what you are arriving at is a gesture drawing. Loose sketching with a matter of a few seconds for each drawing is good training for the mind's reflexes.

AR

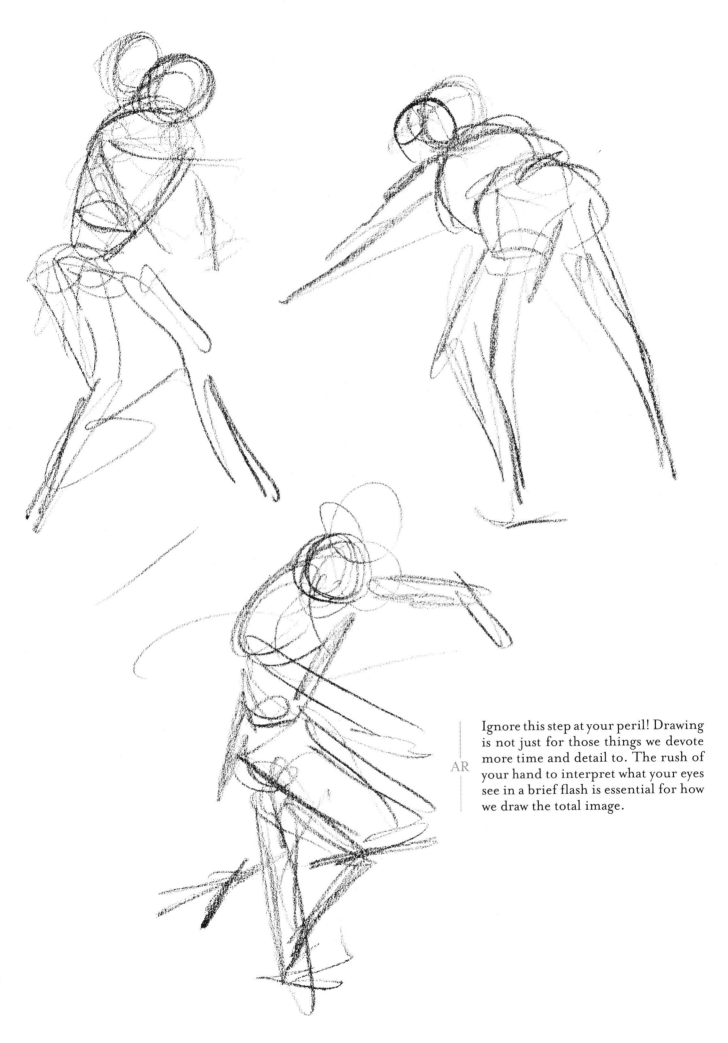

Ignore this step at your peril! Drawing is not just for those things we devote more time and detail to. The rush of your hand to interpret what your eyes see in a brief flash is essential for how we draw the total image.

AR

FIGURE DRAWINGS IN LIGHT AND SHADOW

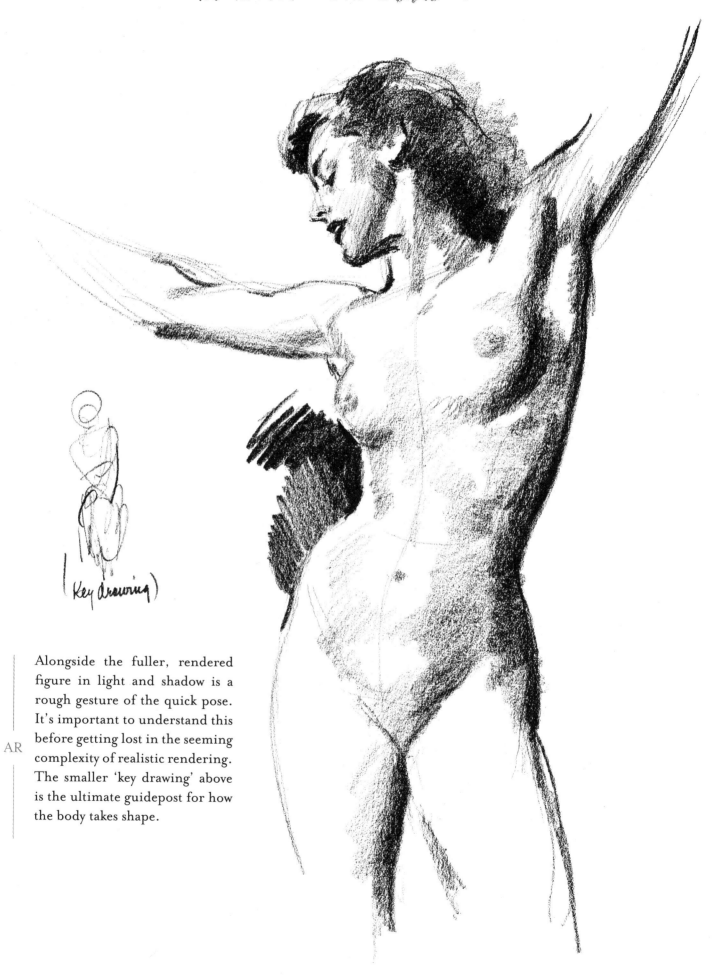

(Key drawing)

AR Alongside the fuller, rendered figure in light and shadow is a rough gesture of the quick pose. It's important to understand this before getting lost in the seeming complexity of realistic rendering. The smaller 'key drawing' above is the ultimate guidepost for how the body takes shape.

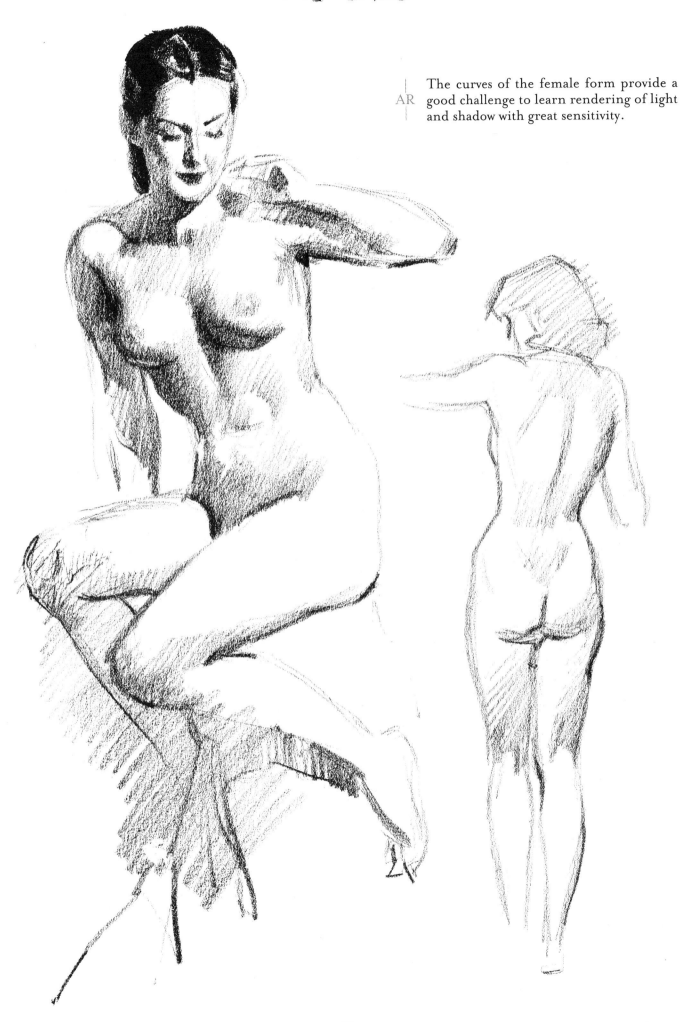

The curves of the female form provide a good challenge to learn rendering of light and shadow with great sensitivity.

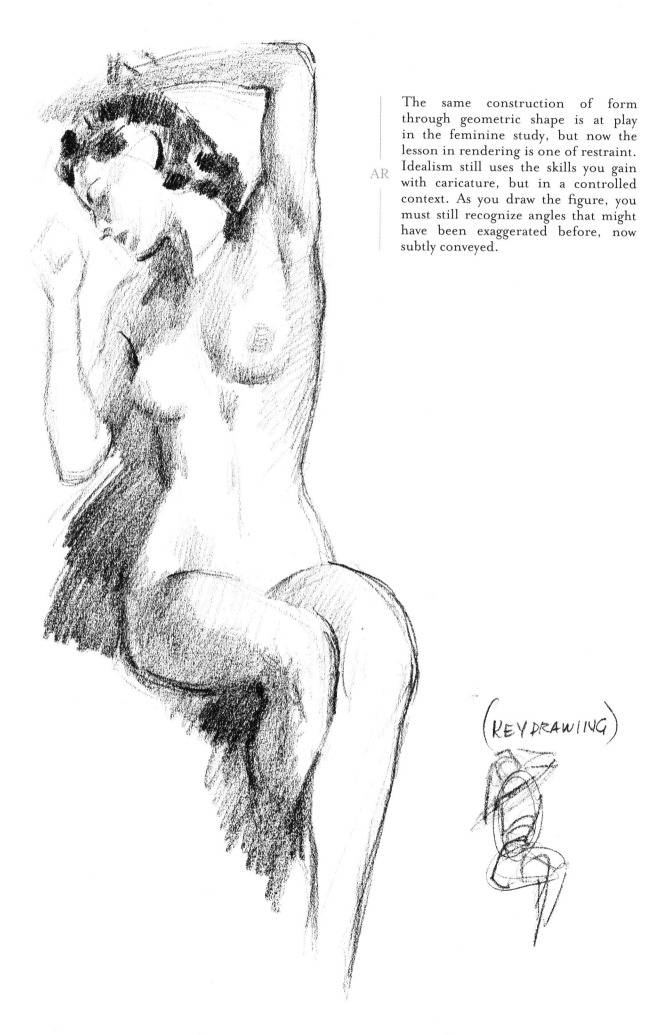

The same construction of form through geometric shape is at play in the feminine study, but now the lesson in rendering is one of restraint. Idealism still uses the skills you gain with caricature, but in a controlled context. As you draw the figure, you must still recognize angles that might have been exaggerated before, now subtly conveyed.

AR

(KEY DRAWING)

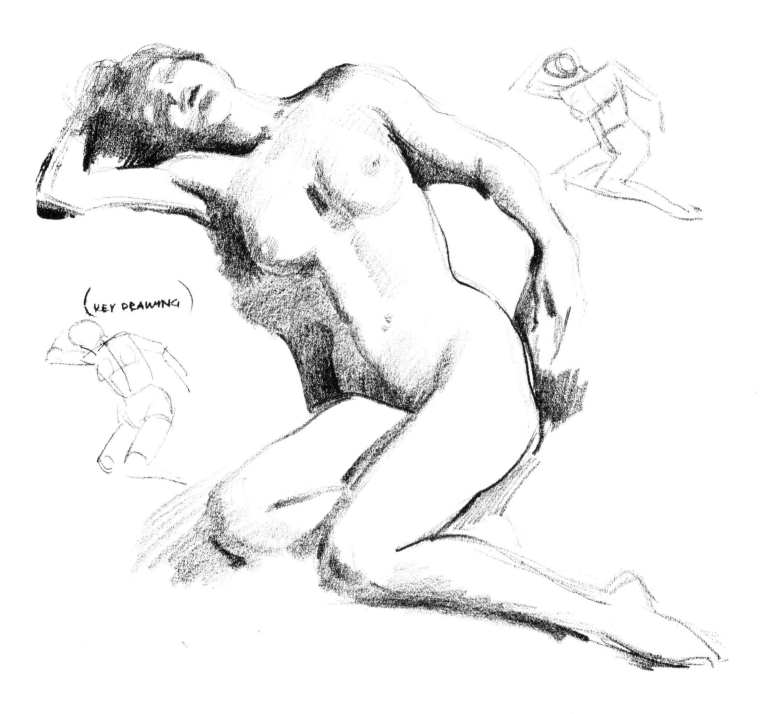

(KEY DRAWING)

A less involved approach where one simply follows a contour outline will miss the turns that exist in the geometric representation of the key drawing. What makes the figure appealing is the greater depth and volume that can be translated when one builds the body from the ground up.

PART THREE

THE
OF

FUN

SKETCHING

This will be filled
up with all kinds of
subjects and drawings.

sort of a gallery/ provide explanation

SKETCHING

When you begin to boil things down, the greatest thrill in art is sketching. No one expects a sketch to be a complete photographic sort of thing. It can be the merest suggestion of form, action, in line alone, or with light and shadow suggesting a more solid thing. Here is where we cut loose and play with our subjects. There are many ways to go at a sketch. The approach is usually based on what we wish to express, or what interested us in the subject in the first place.

We look at a thing or person. Perhaps the thing that impresses us most is the flowing line, or the arrangement. We would then strive to express it in line only. We do not try to get everything in a sketch, everything is too much. If it is a character, or gesture, then we look for the big basic forms first, and then try to build the smaller and more individual forms onto or out of the larger ones. Everything seems to have its particular combination of forms, and when you really begin to form things consciously, those pieces and shapes all tie together to make

up a particular subject—which gets mighty interesting. Sometimes a subject growing out of scribbly lines, showing how you were feeling for the right lines and then finding them, can be so much better than a precise academic sort of thing. It leaves a trace of you, and will be unlike any other drawing ever made. That can be its most attractive quality.

There is a particular charm to the drawing that suggests the blocks that have built it, even in leaving them in. There is quite a trend at this time for drawings that are all line, without shadow or halftones. The point is there is no particular way a sketch must or should be done. The whole charm may be your own peculiar way of expressing yourself. Get it in your mind that you are as free as the breeze to do anything you wish. Make something that looks good to you, regardless of what anyone else has done, is the spirit of sketching.

You will find much hidden charm in ordinary objects or subjects when set down as a drawing, which is lacking in photography. While there

is nothing out of the way in drawing from photos, we do not want the result to look like a photo. Anyone can take a photo these days with fair results, because photography has been simplified to something almost entirely technical and mechanical. There is no point in trying to compete with it. We take from it that which we want, which will help us express ourselves. You do not copy it in the square-inch-by-square-inch manner and come out with anything very creative. You are writing and singing your own song about what you see, and telling us what you feel about it.

You will find several approaches in the following pages, some going after one thing and some another. The ability to make sketches and compositions is part of every good artist's stock. You might say that his sketches are the soul of his work, and nine times out of ten they are actually better than his finished work. They are more direct and spontaneous, since there has not been time to fiddle with them until they become so stressed and overworked and lose the very qualities that make them expressive. All big pictures should start with an idea in sketch form, or a pattern composition of some kind. We want to find out what we are doing, and what the problems are. We do not know just by looking at a subject, we have to try to get things down to know what we are getting into.

If you never get past the sketching stage, even that is most interesting as a hobby and exciting as a pastime. If you have a pad and pencil in your pocket, you never need to be lonely or idle, wondering what to do with your time. Anything you draw is good practice, for everything is line, tone, and proportion. You could kick off your shoe and try to draw it, and see if you can't get the shapes that make up a shoe. Then, someday, you will know more of how to put feet on a figure.

All of your sketches add up in general knowledge. The more knowledge you have about things, the better you will be able to draw them. I think Norman Rockwell loves to paint anything there is.

LINE AND FORM COMBINED

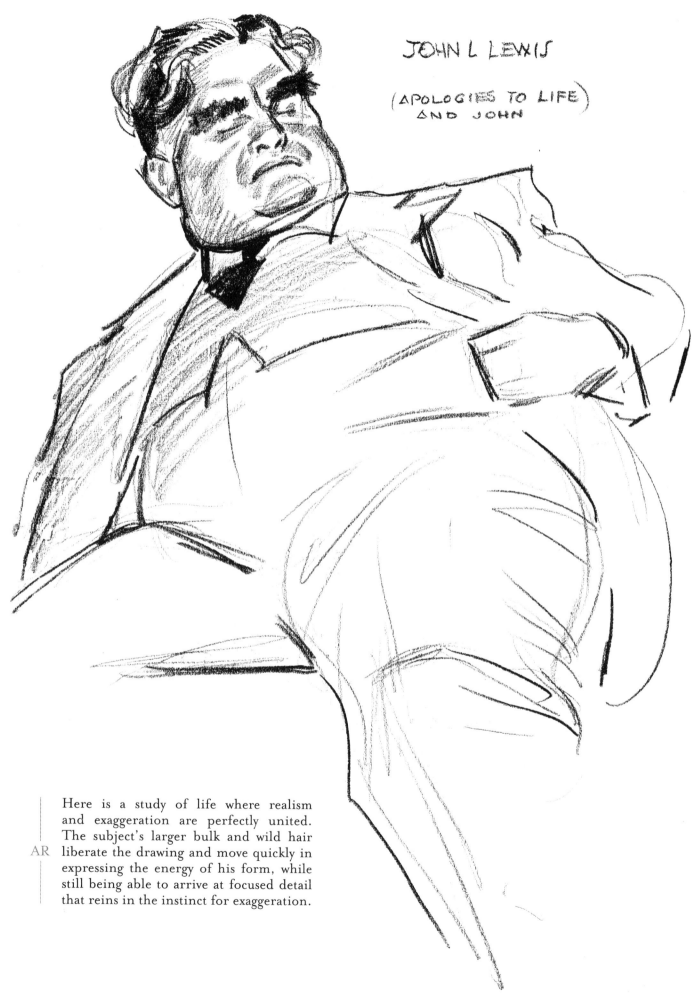

JOHN L LEWIS

(APOLOGIES TO LIFE)
AND JOHN

AR Here is a study of life where realism and exaggeration are perfectly united. The subject's larger bulk and wild hair liberate the drawing and move quickly in expressing the energy of his form, while still being able to arrive at focused detail that reins in the instinct for exaggeration.

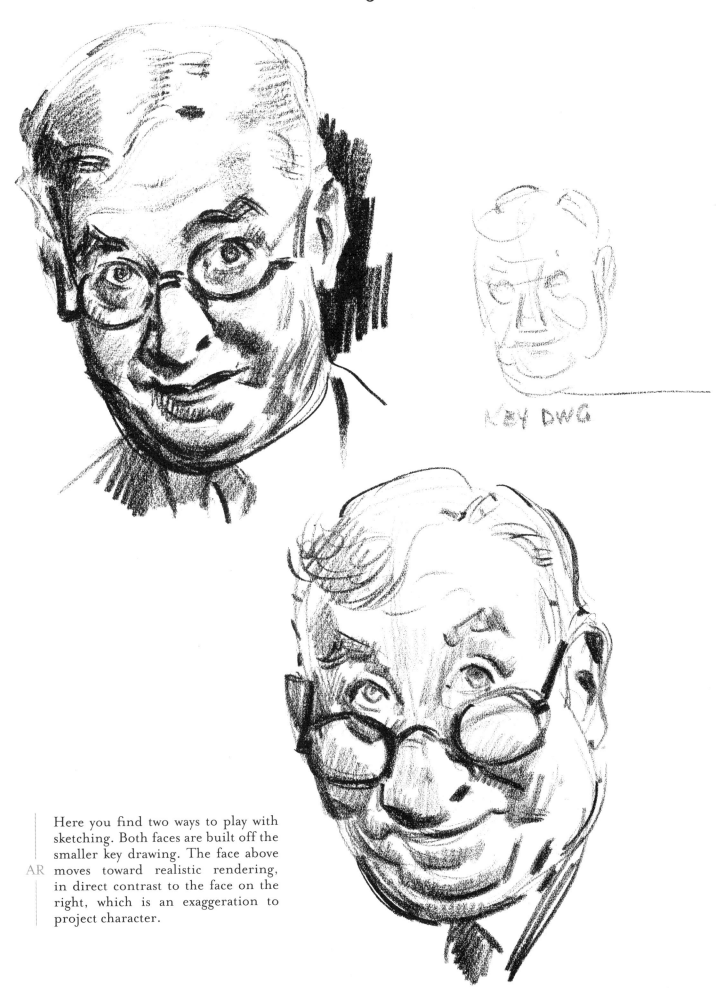

KBY DWG

Here you find two ways to play with sketching. Both faces are built off the smaller key drawing. The face above moves toward realistic rendering, in direct contrast to the face on the right, which is an exaggeration to project character.

SOLID OR TONAL CARICATURE

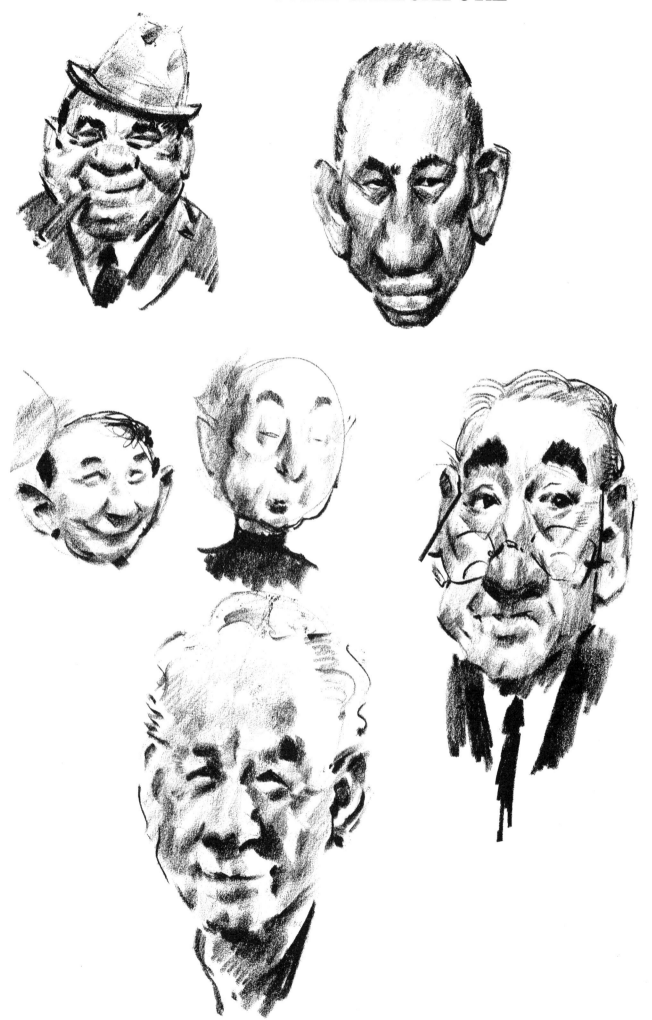

PORTRAIT SKETCHING

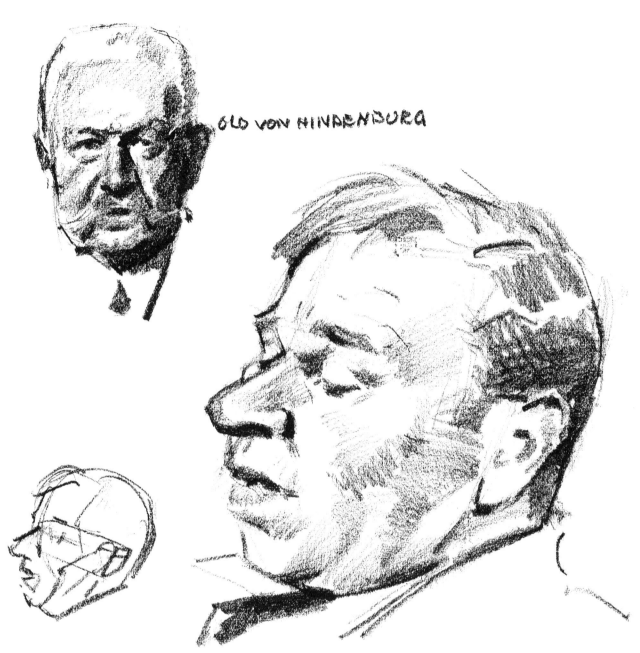

OLD VON HINDENBURG

WALLACE BEERY
FROM PHOTO BY RUDOLPH H. HOFFMANN

Note — ask your legal dept if I can use such copy so long as credit is given? Or must we hunt the guy up and get permission?

Portraits like these utilize the skills of rough sketching, which establishes tonal shifts through quick movement of line. The likeness is intact, but imbued with an energy found only in life drawing.

AR

TONE SKETCHING

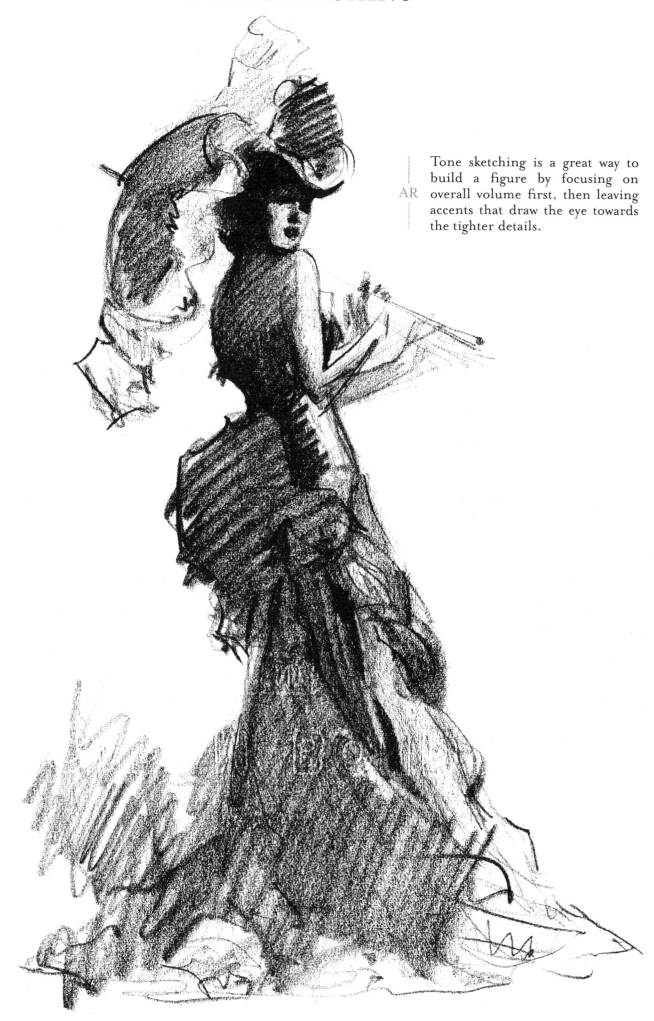

Tone sketching is a great way to build a figure by focusing on overall volume first, then leaving accents that draw the eye towards the tighter details.

ACCENT SKETCHING

Sketching the form with special emphasis on parts of the body, shadows, or clothing can create an impression of a more detailed drawing. Accentuating key details guides in focusing on what you want the viewer to absorb.

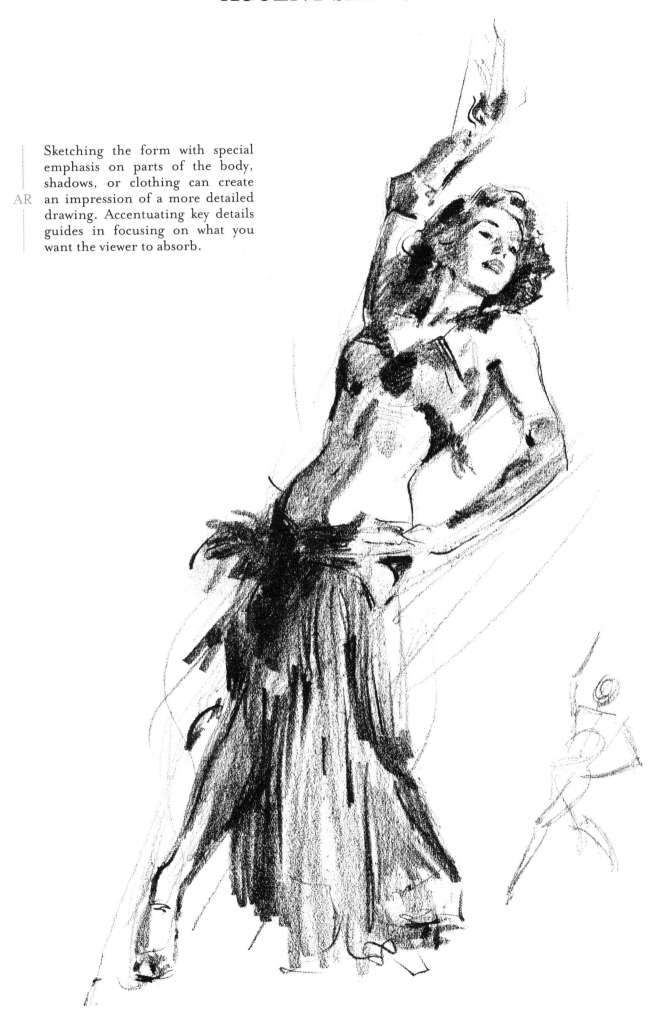

SCRIBBLE SKETCHING

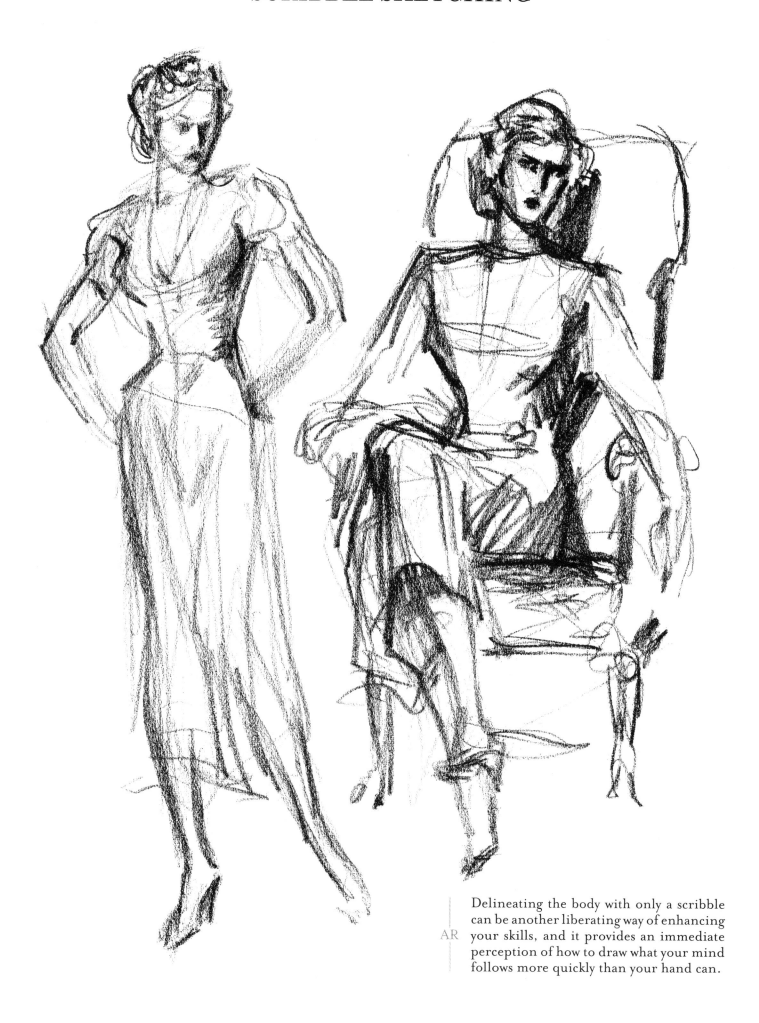

Delineating the body with only a scribble can be another liberating way of enhancing your skills, and it provides an immediate perception of how to draw what your mind follows more quickly than your hand can.

BLOCK SKETCHING

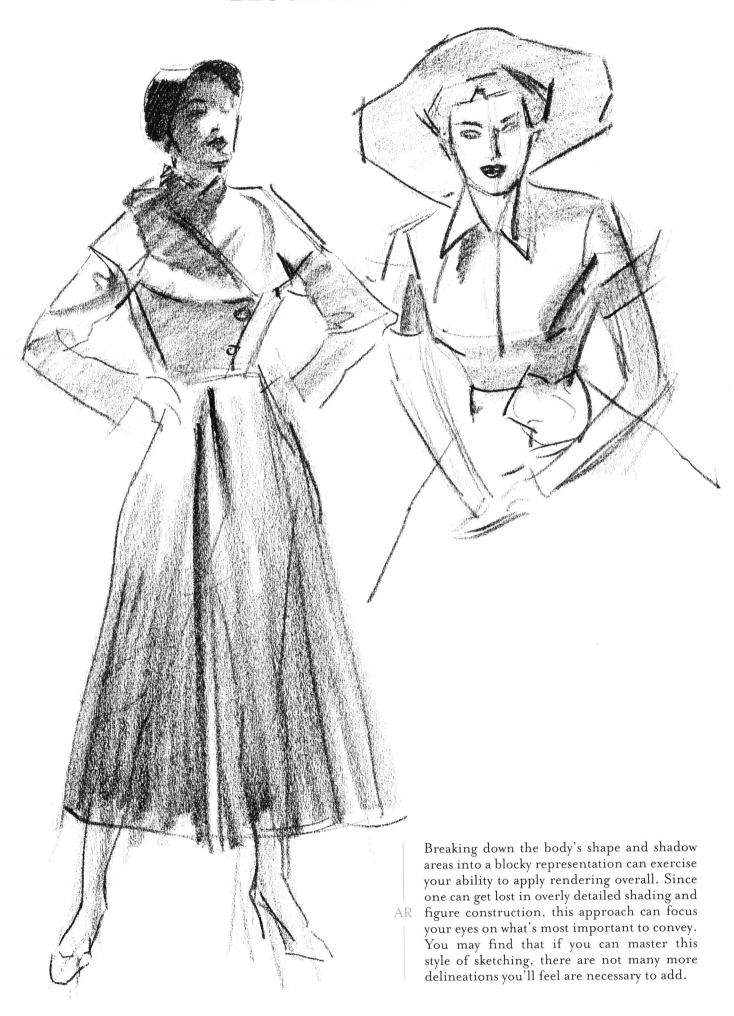

Breaking down the body's shape and shadow areas into a blocky representation can exercise your ability to apply rendering overall. Since one can get lost in overly detailed shading and figure construction, this approach can focus your eyes on what's most important to convey. You may find that if you can master this style of sketching, there are not many more delineations you'll feel are necessary to add.

SHADOW SKETCHING

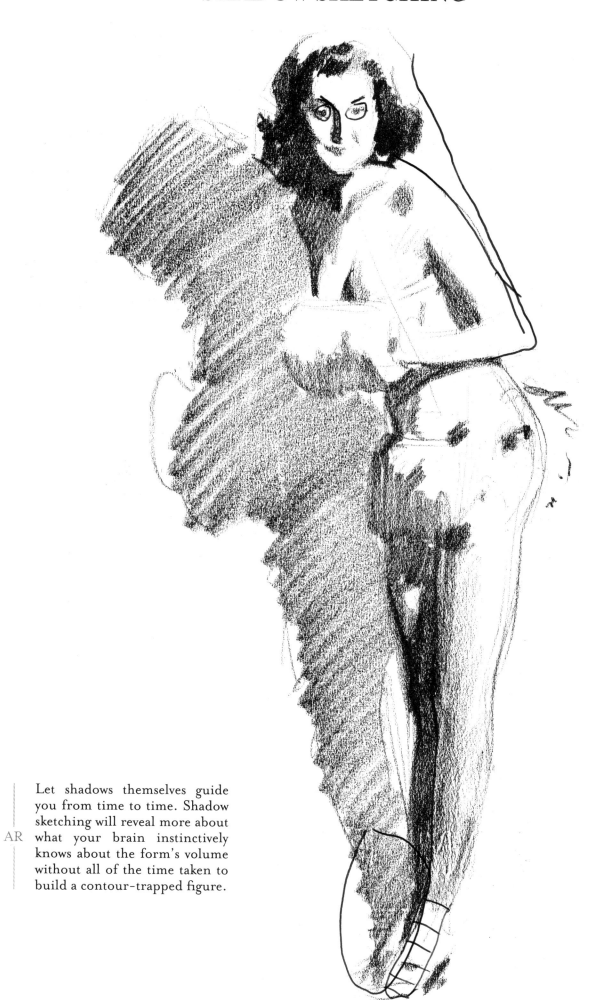

Let shadows themselves guide you from time to time. Shadow sketching will reveal more about what your brain instinctively knows about the form's volume without all of the time taken to build a contour-trapped figure.

LINE SKETCHING

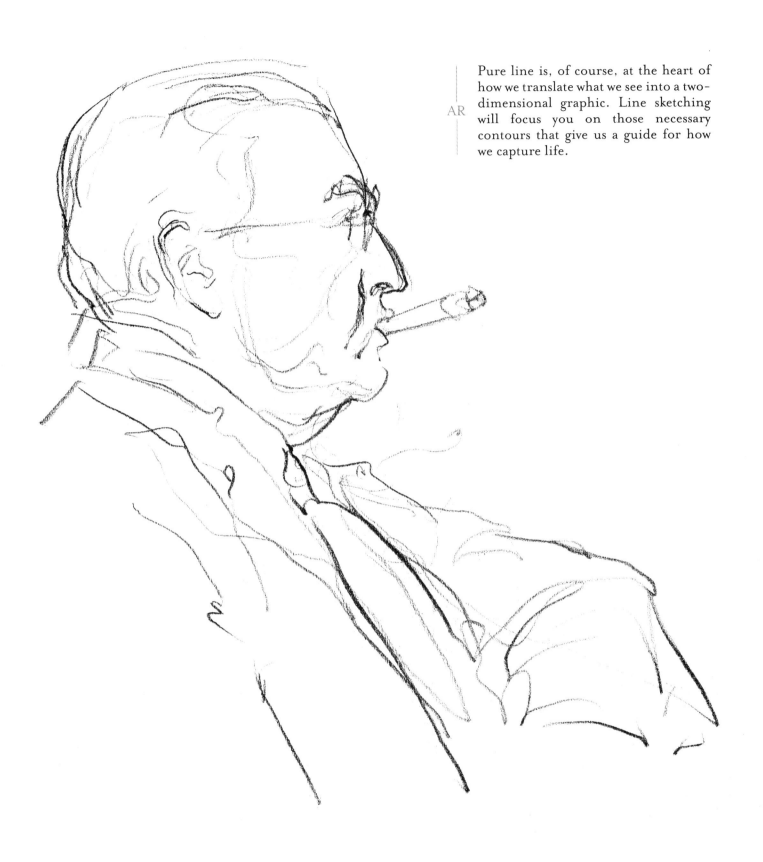

Pure line is, of course, at the heart of how we translate what we see into a two-dimensional graphic. Line sketching will focus you on those necessary contours that give us a guide for how we capture life.

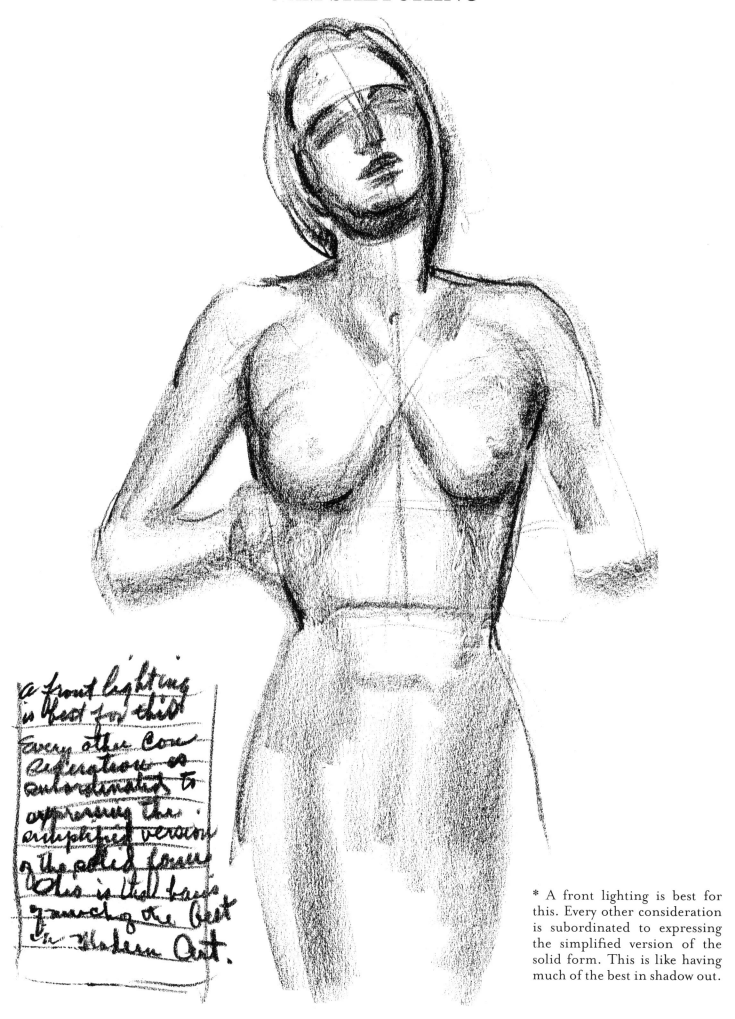

a front lighting is best for this. Every other consideration as subordinated to expressing the simplified version of the solid form. This is still having much of the best in Modern Art.

* A front lighting is best for this. Every other consideration is subordinated to expressing the simplified version of the solid form. This is like having much of the best in shadow out.

CHARACTER SKETCHING

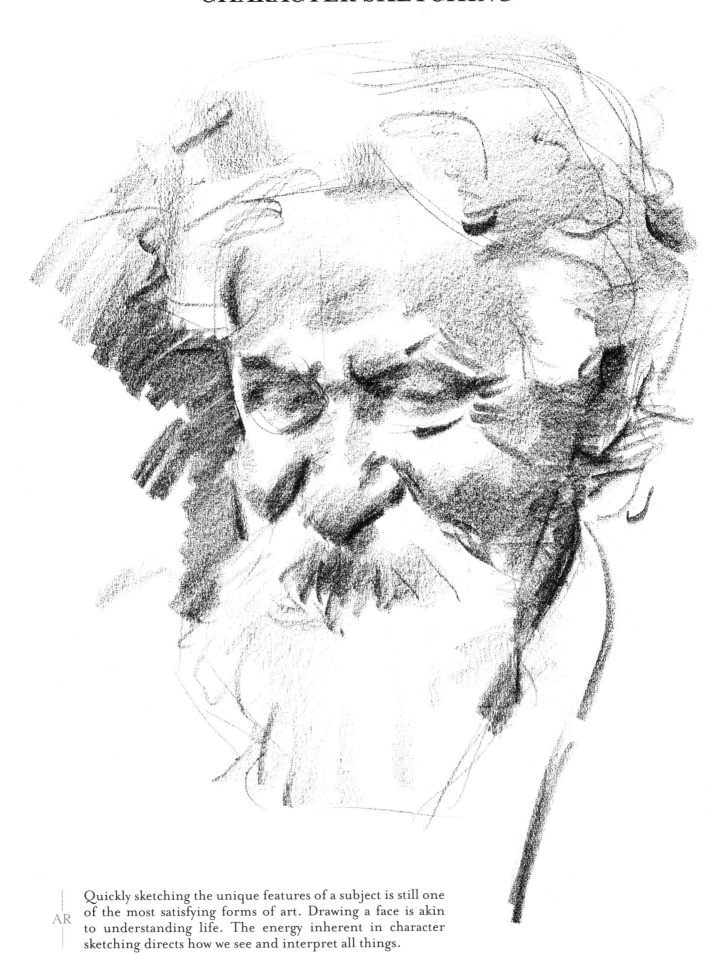

Quickly sketching the unique features of a subject is still one of the most satisfying forms of art. Drawing a face is akin to understanding life. The energy inherent in character sketching directs how we see and interpret all things.

SUNLIGHT SKETCHING

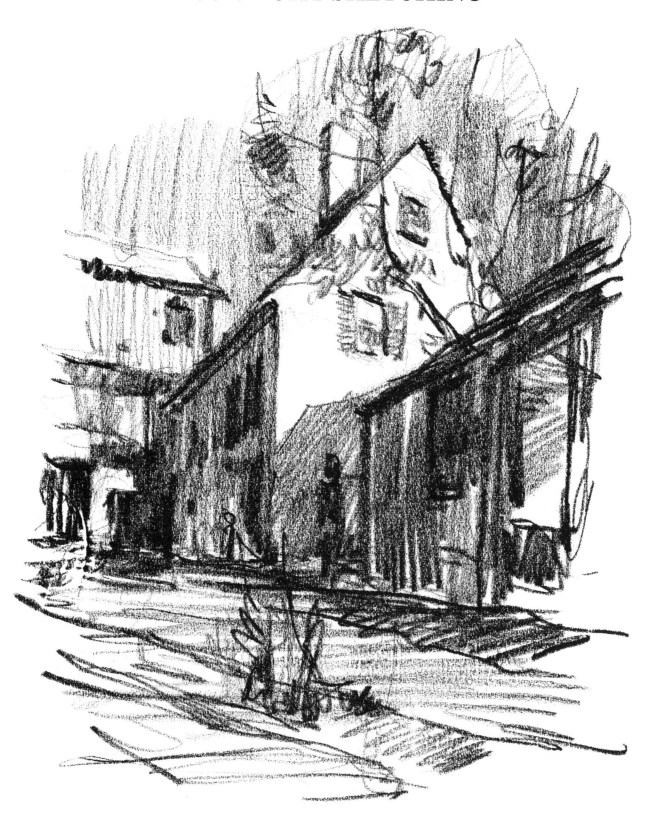

To further your appreciation of the laws of perspective, you should seek out photos to study or real locations to test your skills on the subject.

DAYLIGHT OR DIFFUSED LIGHT SKETCHING

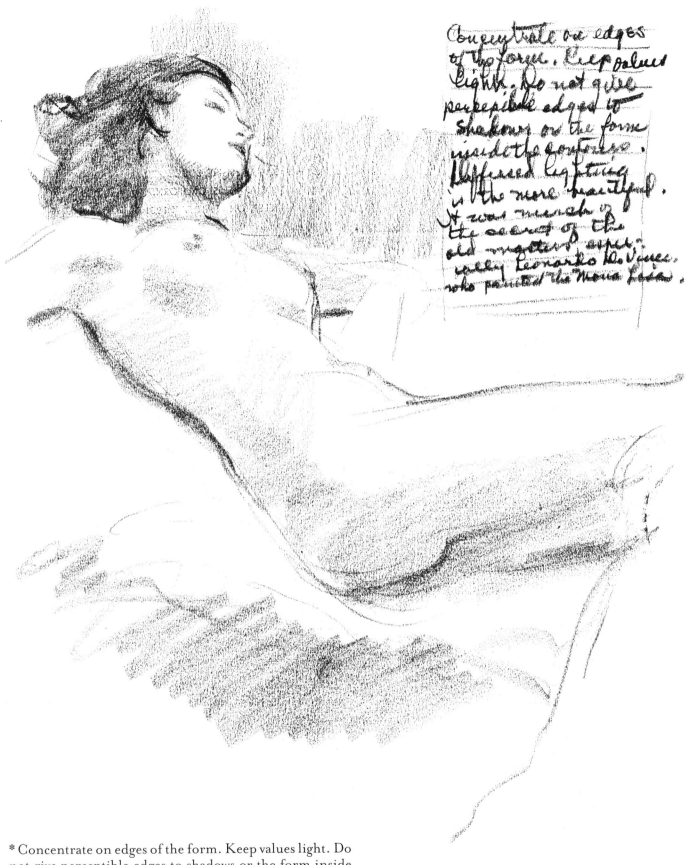

* Concentrate on edges of the form. Keep values light. Do not give perceptible edges to shadows or the form inside the contours. Diffused lighting is the more beautiful. It was much in the accent of the old masters, especially Leonardo da Vinci, who painted the Mona Lisa.

MOTION SKETCHING

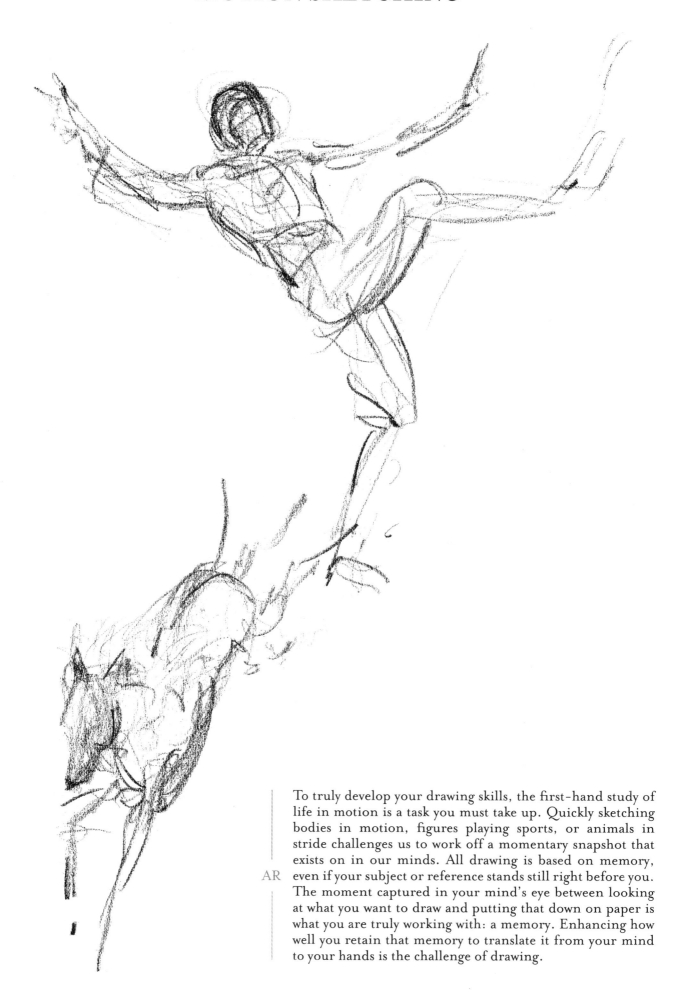

To truly develop your drawing skills, the first-hand study of life in motion is a task you must take up. Quickly sketching bodies in motion, figures playing sports, or animals in stride challenges us to work off a momentary snapshot that exists on in our minds. All drawing is based on memory, even if your subject or reference stands still right before you. The moment captured in your mind's eye between looking at what you want to draw and putting that down on paper is what you are truly working with: a memory. Enhancing how well you retain that memory to translate it from your mind to your hands is the challenge of drawing.

PATTERN SKETCHING

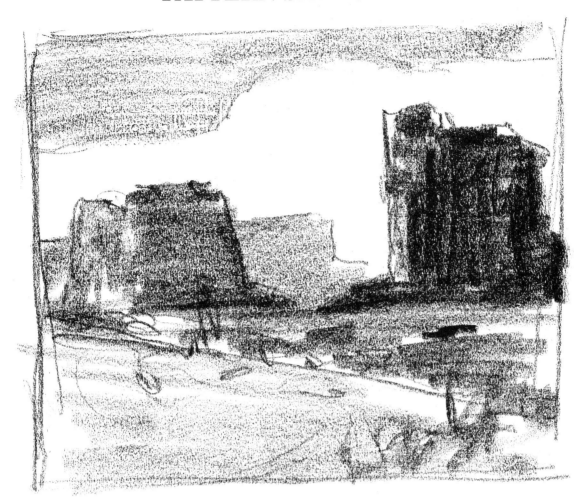

* Pattern sketching is mainly for composition, where everything is sacrificed for the design of the larger tonal patterns. Any intended picture should be planned for its patterns. Pictures may be composed on the spot, often some quick notations can result in a fine thing, for the little studies are the means of getting at good arrangement and design.

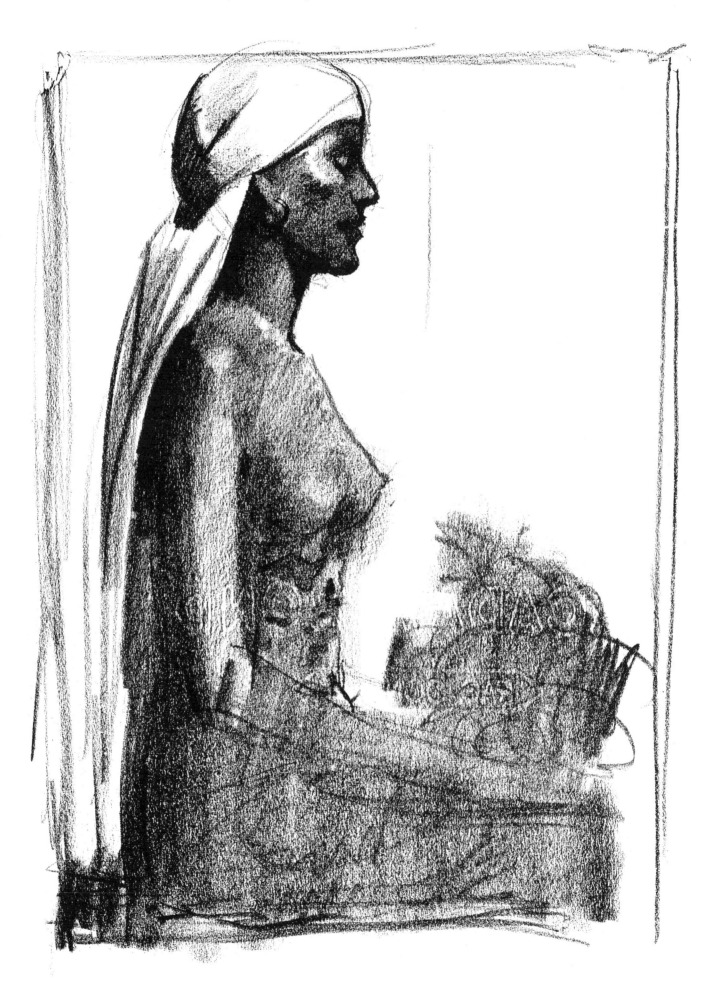

PATTERN SKETCHING

CLOSING CHAT

Dear Reader,

There is one point I want to make before I leave you. That is that for art to be 'art', and to be good, it cannot be reduced to complete formula. All anyone can ever do is to develop an approach by themselves out of the basic fundamentals that are possible to be taught to you. I repeat: when you know your notes and bars, only then can you really play. But—sometimes the rhythm and feeling for it is so strong within you that you find a way of expressing yourself without them. Drawing is also like that. People can and do play music entirely from within. They call it 'playing by ear'. What they really mean is much more. Let's not give too much credit to the ear. Anyone else can hear about as well, but it does not mean that he has the capacity to work at it until he can put the sounds together that make music. We all have some music in our souls, and just a few of us ever do much about it. By the same token, we all have some appreciation of beauty of form, line, tone, and color. It is possible, then, to draw without a lesson, in our own ways—but it is much easier to learn if we use the fundamentals, which are truly simple.

Anything can only be so high, so wide, and so thick. If we can learn to measure these things, and then set them down in perspective, we can draw them. But to draw them we have to think of them as transparent, made up of parts within the outlines, not just outlines. Such parts make the outlines. Then we know that anything we see has light on it, and that brings out the shapes that make it exist. As we go on, we learn that light has only one way of working, always producing the simple sequence of light, halftone, and shadow, and that such sequences are always the result of the angles of the surface in relation to the direction of light. Getting that, with your line and proportion, you have all that can be taught. From there on, you feel your own way. There is nothing else.

Talent is knowledge and the reverse. One can't get along without the other. Talent is really the capacity for staying with it until we know a lot about it. Your talent is expressed much

more in your ideas, or your selection of what you draw, than in your technical ability to draw them. You can draw anything under the sun, so long as you go and get sufficient information about it. We can only fake the things we know thoroughly—otherwise we just put down the evidence of what we do not know.

The most wonderful part of developing any creative faculty is that you always have an interesting companion, you are never wholly alone, and you have a companion to turn to when all else might be boredom. You will be a happier person inside, and it will reflect in your whole make-up. We truly get pleasure from the inside out, much more than from the outside in. When we are happy, we stay younger. Psychiatry has recognized the therapeutic value of creativeness. It gets us to thinking about something besides ourselves and our shortcomings, or our actual troubles. That mental rest does us lots of good. We are more able to face our inadequacies. You usually find that the creative person loves life, even has a zest for it, for he wants the time to do things.

Drawing some funny little cartoons can raise your spirits just as much as whacking out some lively music on the piano, even if it doesn't quite make the grade. Who really cares? The fun is in the doing. Really get acquainted with your pencil and some of the happy things it can do for you. This book can be no more than a starter. But keep it going until you begin to get a little of the thrill that is in it. If you will stop looking so much for secret formulas, and look at things themselves, you will really start learning—and fast. No artist was ever good who did not go to the real source: that of life itself. Only a very small part of it is in books, but art is everywhere in the world about you, and it's perfectly free. All it ever costs is your own interest and perseverance.

ANDREW LOOMIS

Good Luck

"Andy Loomis.."

STUDIO - - 9335 WILSHIRE BOULEVARD
LOS ANGELES, CALIFORNIA
TELEPHONE FAIRFAX 1951